M000287008

Tifton, Georgia

IN VINTAGE POSTCARDS

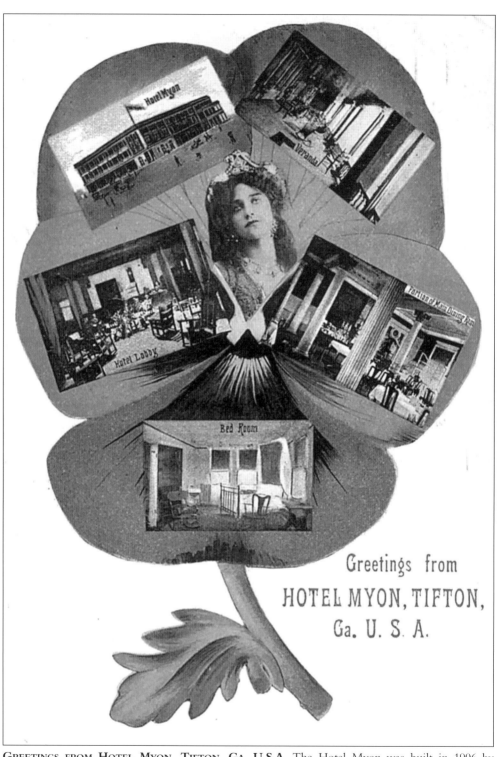

GREETINGS FROM HOTEL MYON, TIFTON, GA. U.S.A. The Hotel Myon was built in 1906 by Mr. I.W. Myers.

POSTCARD HISTORY SERIES

Tifton, Georgia
IN VINTAGE POSTCARDS

William R. Wells

ARCADIA

Copyright © 2002 by William R. Wells.
ISBN 0-7385-1448-9

Published by Arcadia Publishing,
an imprint of Tempus Publishing, Inc.
2 Cumberland Street
Charleston, SC 29401

Printed in Great Britain.

Library of Congress Catalog Card Number: 2002104391

For all general information contact Arcadia Publishing at:
Telephone 843-853-2070
Fax 843-853-0044
E-Mail sales@arcadiapublishing.com

For customer service and orders:
Toll-Free 1-888-313-2665

Visit us on the internet at http://www.arcadiapublishing.com

This book is dedicated to Capt. Henry Harding Tift, founder of Tifton, and to my late parents,

Mary Frances Sikes Wells and Willis Daniel Wells.

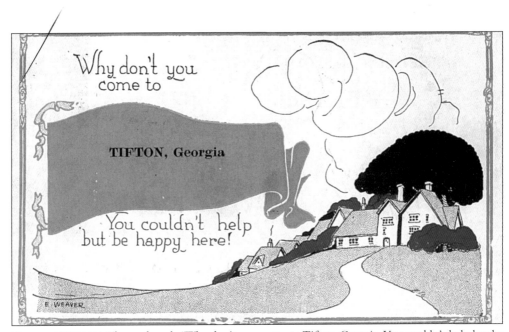

COME TO TIFTON. The card reads "Why don't you come to Tifton, Georgia. You couldn't help but be happy here," and is postmarked April 12, 1927 with a 2¢ stamp.

CONTENTS

ACKNOWLEDGMENTS

Thanks to Dick Marti for his idea and driving force that inspired me to author this book. Thanks also to Gary Doster, Norma and Billy Lankford, Ann and Claude Davis, Martha Sue Pittman, Elizabeth Lennon, Rosalie Shepherd, Rev. John S. Gibbs Sr., Carolyn W. Flynt, Frances F. Harris, Holly B. Hall, Grace Tucker, and Nancy Coleman for their donations and/or knowledge of Tifton and Ty Ty. To my wife, Ginny, who was my advisor, supporter, and proofreader, many thanks.

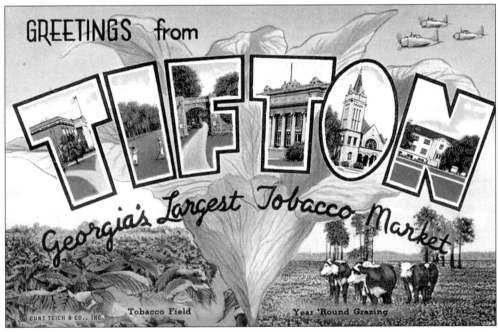

TOBACCO IN TIFTON. This World War II postcard from the 1940s reads, "Greetings from Tifton. Georgia's Largest Tobacco Market."

INTRODUCTION

In the untamed territories of America, the settlers saw opportunity—opportunity for a fulfilling life. When they arrived from Europe, Asia, and Africa, the settlers took advantage of the opportunities to make good use of the land's abundant resources, all in the pursuit of happiness.

South Georgia was inhabited by tribes of the Creek Indian nation. As the areas became more populated with immigrants, pressure was put on the government to acquire more land from the Native Americans for settlement.

The area where Tifton is located was divided into three large counties: Early, Irwin, and Appling. The future Tifton area was thereby located in Irwin County. Later, Berrien County was formed from territory taken from neighboring Irwin, Lowndes, and Coffee Counties

A tremendous crowd gathered in Tifton for a celebration. It was a time for rejoicing—a time for speeches, barbecues, and bonfires. On Wednesday afternoon August 16, 1905, at exactly 5:20 p.m., Tift County was born! The new county was composed of 90 square miles from Berrien County, 95 from Irwin County, and 68 from Worth County.

The founding of Tifton had occurred years earlier when Henry Harding Tift migrated to the Albany area to work for his uncle, Nelson Tift. Henry had worked five years as a marine engineer on lines operating between New York and Southern coast ports, when his uncle persuaded him to come south. In 1870 he arrived and worked for his uncle—the founder of Albany—for two years.

In 1872 Captain Tift came to Berrien County (now Tift County) to build his sawmill. At first the little settlement was called "Slab Town" because the sawmill hands built their shacks out of lumber slabs from the mill. Captain Tift preferred "Lena" after his sweetheart back in Connecticut; however, George Badger, a mill worker, resolved to be the first to honor the founder of the village. He climbed a pine tree and nailed a placard with the bold letters TIFTON, a condensation of "Tift's Town."

The sawmill settlement that became Tifton is now inhabited by approximately 15,000 residents and Tift County has 38,000 citizens. Smaller towns are located within Tift County, including Ty Ty, Omega, Eldorado, Chula, Sunsweet, and Brookfield.

Tifton is filled with buildings dating back to the 1800s, an historic district which has preserved many downtown buildings, churches, and homes. Tifton also has beautiful parks, excellent schools, a junior college, an experiment station, golf courses, industrial parks, and the Agrirama (a living 1800s legacy of Georgia heritage).

This book is a compilation of vintage postcards and pictures of the Tifton area with a small section devoted to Ty Ty.

Postcards were a popular means of communication beginning in the 1890s. Prior to 1907 one was only allowed to use one side of the card for the address; therefore, one had to write on the picture side of the card.

After 1907 a space on the left of the card could be used for a message and right side for the addressee, therefore not "messing up" the beautiful scenery/picture on the other side. The "penny postcard" was very popular for many years. Now the cards come in every size and shape and continue to be a great way to keep family and friends informed of one another's travels.

The author was born in Tifton, raised and schooled in Tifton, and his children were born and raised in Tifton; however, his wife, like Captain Tift, was born in Connecticut. He retired from the Department of Transportation in Tifton and is proud to be a TIFTONITE!

TIFTON BUILDINGS. The letters spelling TIFTON feature buildings in the city. The Tift County Courthouse is shown in the letter "F."

One
IN THE BEGINNING

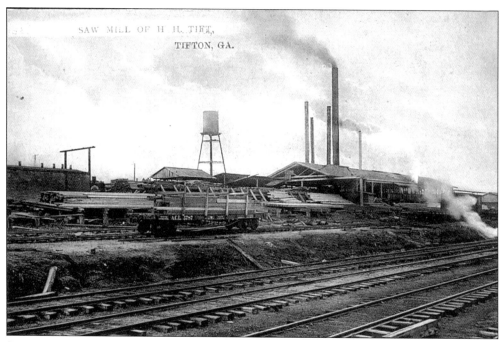

SAWMILL IN TIFTON. Pictured is the sawmill that H.H. Tift built—this was the beginning of Tifton.

THE COMMISSARY. Henry Harding Tift built the Commissary in 1872. It has been moved and preserved at the Georgia Agrirama, which is in Tifton.

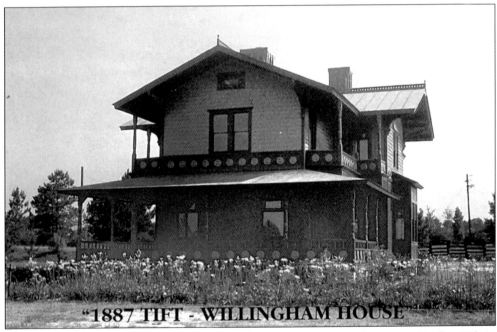

"1887 TIFT - WILLINGHAM HOUSE"

THE TIFT-WILLINGHAM HOME. Built on Second Street by Tifton's founder, Henry Harding Tift, in 1887, the home has been moved to the Georgia Agrirama and has been beautifully restored. Mrs. Tift was the former Elizabeth "Bessie" Willingham.

Two
DOWNTOWN TIFTON

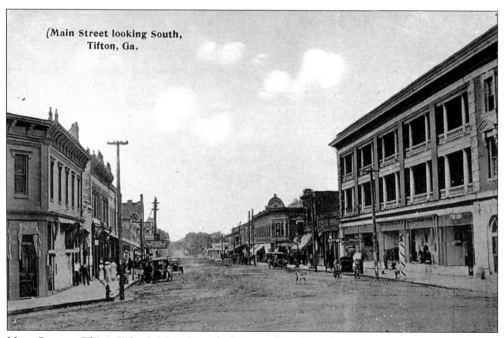

MAIN STREET. This is Tifton's Main Street looking south in the early 1900s.

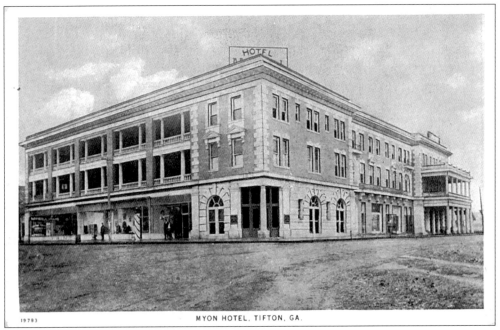

THE HOTEL MYON. This hotel was built to replace the Sadie Hotel, which had burned. The Myon is still standing on the corner of Main Street and First Street. Myon is a combination MYers and TiftON. The hotel was built by Mr. I.W. Myers in 1906.

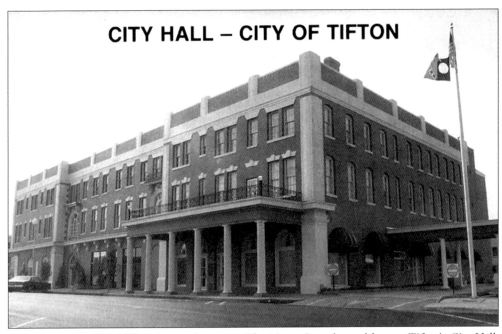

CITY HALL. The Hotel Myon is now known as The Myon Complex and houses Tifton's City Hall, businesses, and apartments.

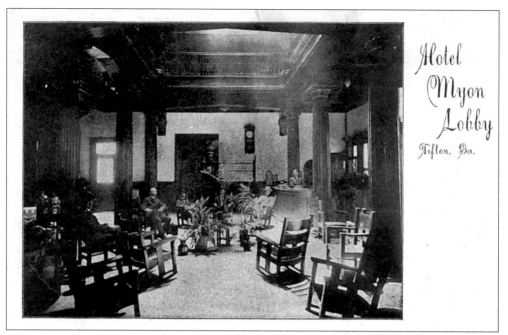

AN EARLY SCENE OF THE LOBBY OF THE HOTEL MYON. The lobby is brightened with sunlight from the third-floor-ceiling skylight.

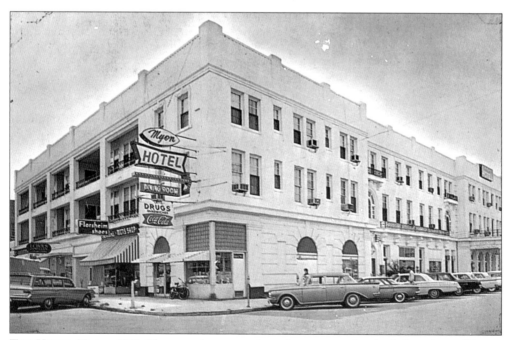

THE HOTEL MYON, 1960. The second-story porch roof was removed and window air-conditioners were added. Also pictured are 1960s-style automobiles and signs.

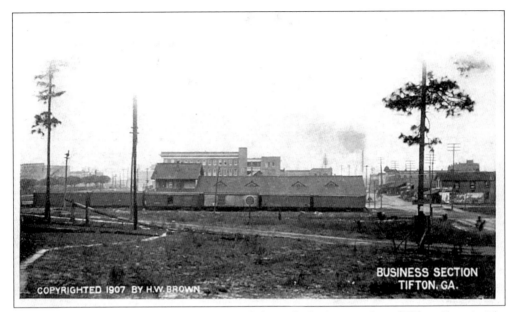

THE BUSINESS SECTION. This pre-1907 postcard shows the business section of Tifton, Georgia. The Hotel Myon and Southern Railroad Depot are pictured. The depot has been replaced with a parking lot..

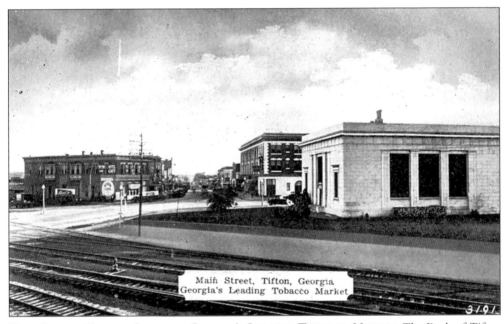

MAIN STREET, TIFTON, GEORGIA—GEORGIA'S LEADING TOBACCO MARKET. The Bank of Tifton (now the Bank of America) is the white marble building. Behind the bank is The Hotel Myon and across the street are the buildings that formerly housed The Cigar Store and The Byron Restaurant. A Mexican restaurant is located in these buildings now.

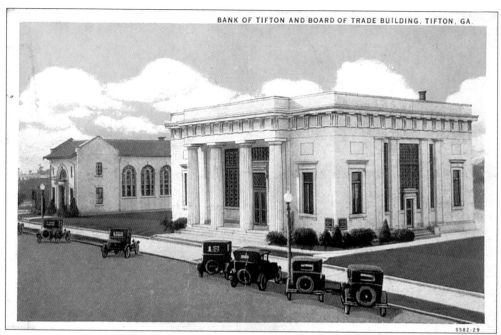

BANK OF TIFTON AND BOARD OF TRADE BUILDING. The Bank of Tifton is now Bank of America and the Board of Trade Building is now Parker Insurance Co. They are located on First Street.

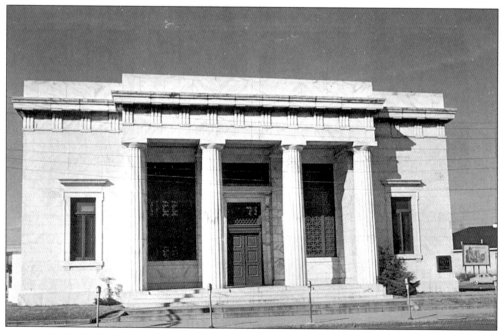

THE BANK OF TIFTON. This is the building before the additions and numerous name changes. Note the parking meters, the Coca-Cola sign, and the old car in the background.

15

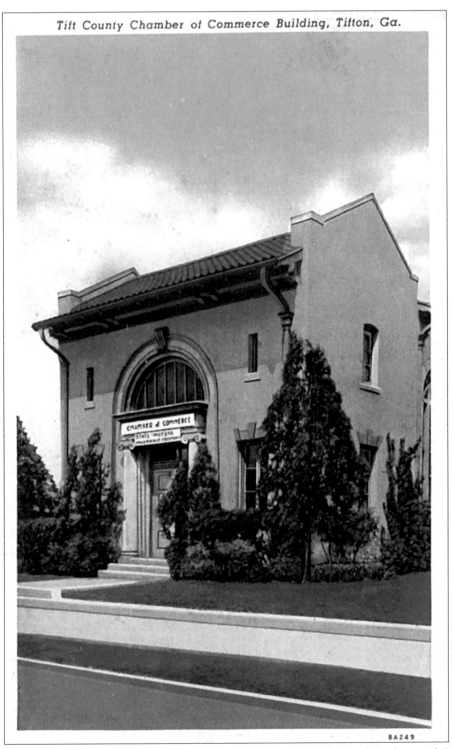

Tift County Chamber of Commerce Building, Tifton, Ga.

CHAMBER OF COMMERCE. Built as the Board of Trade Building in 1917 by Frank Scarboro and Co., it was later used as the Chamber of Commerce. The building now houses Parker Insurance Co.

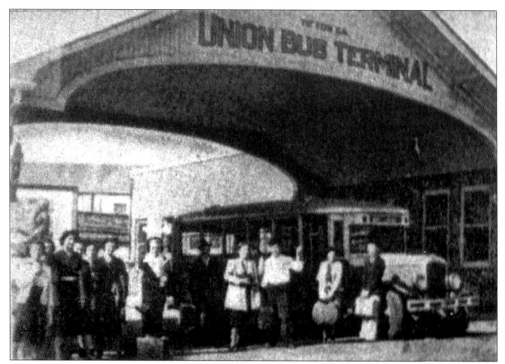

UNION BUS TERMINAL AND RESTAURANT. College students are arriving in the early 1930s. Back then college students did not have automobiles. The terminal later became the Greyhound and Trailways Bus Station. It was eventually torn down to make way for the drive-in windows of the bank.

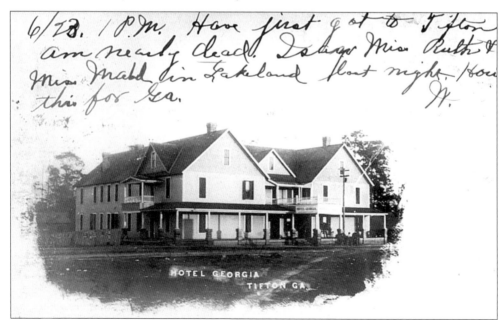

THE HOTEL GEORGIA. This pre-1907 card shows the Hotel Georgia, which was built in 1905 on Main Street. The hotel contained 30 rooms, with offices, parlors, and dining rooms on the first floor. It burned in 1913.

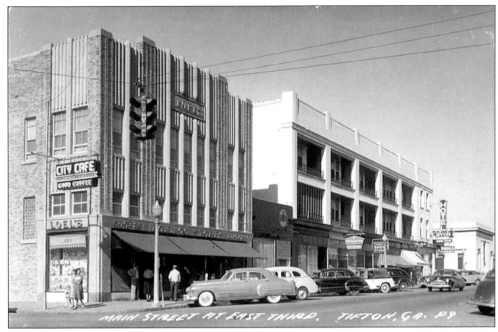

MAIN STREET LOOKING NORTH. Loel's 5¢, 10¢, and 25¢ store is on the corner. The little building next door with the black facade was once the Nifty Hat Shop. The Hotel Myon and Bank of Tifton are also shown.

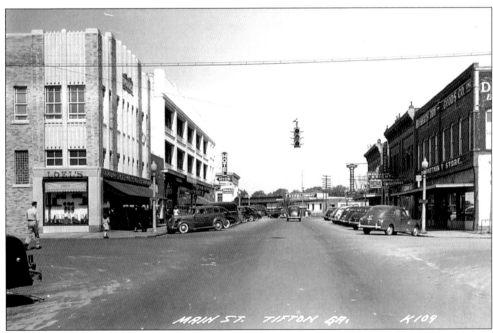

MAIN STREET LOOKING NORTH. This is a slightly different view of Main Street looking north. On the right is Roberts Dry Goods Store and the H.V. Kell Co. is in the distance.

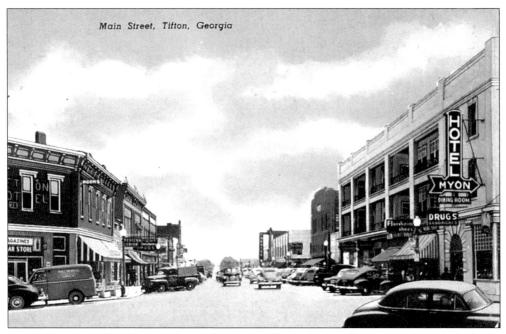

Main Street Looking South, Late 1940s. Main Street looks basically the same today except for the signs and automobiles.

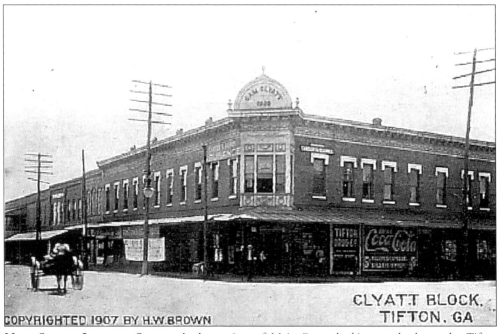

Main Street Looking South. A closer view of Main Street looking south shows the Tifton Drug Co. The drugstore later became Pinkston's Drug Store and is now Guy's Drug Store. This is a pre-1907 postcard.

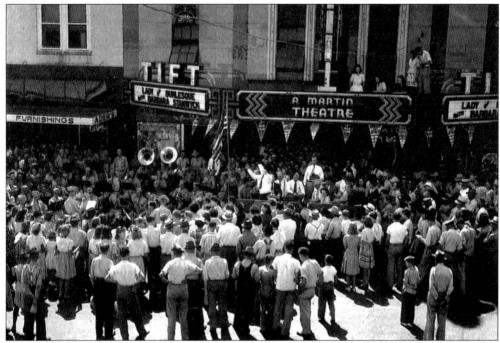

TIFT THEATRE. On September 9, 1943, a War Bond rally was held in front of the Tift Theatre. *Lady of Burlesque* starring Barbara Stanwyck was showing. The author, at age 11, is standing alone in the right side of the picture. He did not know about this picture until recently, when he won it in an auction on eBay. He was shocked when he realized he was in the picture.

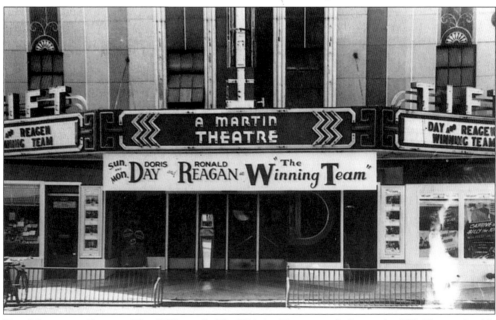

THE MOVIES IN TIFTON. The 1952 movie *The Winning Team* was playing at the Tift Theatre in this image. It starred actor Ronald Reagan who later became our 40th United States President.

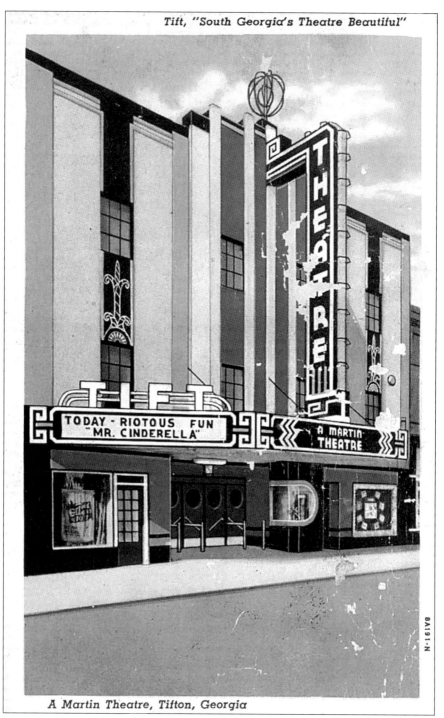

A Martin Theatre, Tifton, Georgia

TIFT THEATRE. "South Georgia's Theatre Beautiful," opened February 22, 1937. With its magic eye operating doors and water fountains, the theatre was an innovation in this section of Georgia. The Tift Theatre has been restored and is now used for movies, plays, pageants, and concerts.

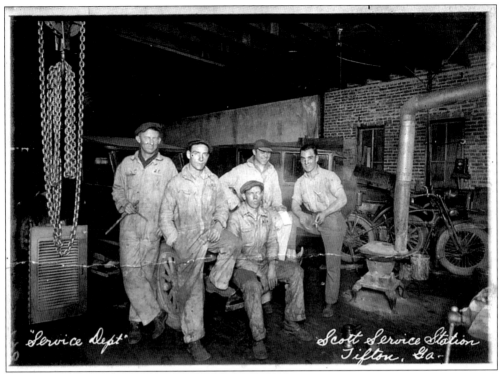

SCOTT SERVICE STATION. This service station was located next door to the Ford Building on South Main Street. The service department employees are shown. The third man standing from the left is Tiftonite L.A. Scott's father, L.A. Scott Sr.

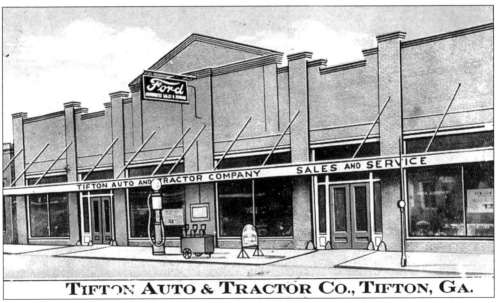

TIFTON AUTO & TRACTOR CO. This building was constructed in 1918 by Mr. I.L. Ford and was later used as the Tifton Auto and Tractor Co. During the 1940s and 1950s, it was the location of the General Motors dealership. It is now a furniture store.

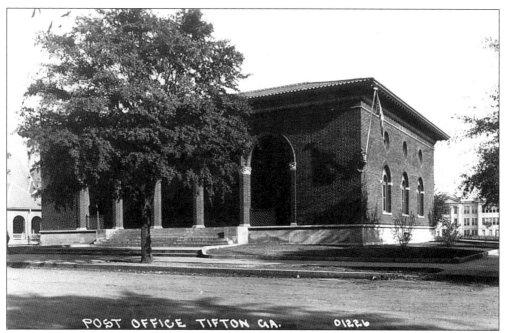

TIFTON POST OFFICE. The post office was built in 1913 on Love Avenue next to the First Methodist Church. It is now the Tifton-Tift County Public Library. Tifton High School (now Tift County Administration Building) is in the background.

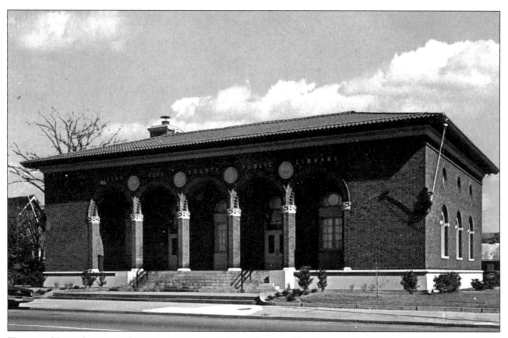

TIFTON-TIFT COUNTY PUBLIC LIBRARY. The old post office is now the Tifton-Tift County Public Library. A large addition has been added to the back of the building with a new entrance off Library Lane (formerly known as New Street). Mrs. J. Sara Paulk is head librarian.

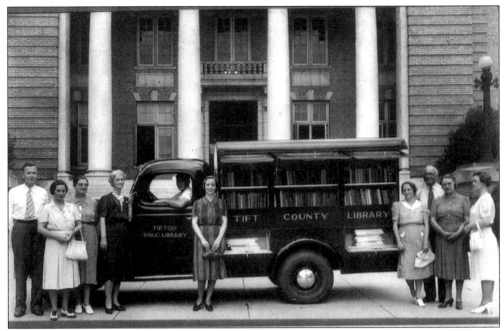

TIFTON'S FIRST BOOKMOBILE. Tift County and Library officials gathered in front of the Tift County Courthouse for this 1940 picture. Pictured from left to right are C.F. Hudgins, Mrs. Josie Clyatt, Mrs. Dan Sutton, Mrs. Nick Peterson, E.G. Thornhill (bookmobile driver), Mrs. Estelle Fischer, Mrs. C.B. Culpepper, Mayor S.A. Youmans, unidentified, and Mrs. Billie Ellis.

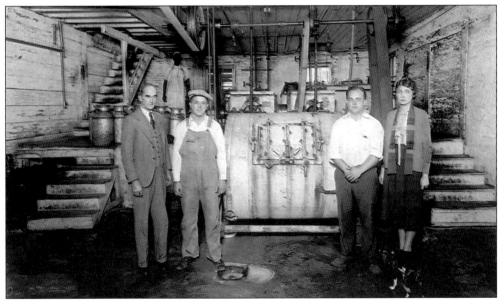

TIFTON ICE CREAM AND CREAMERY. During this time, there was a cage of monkeys in front of the store. People loved to come to the ice cream shop for a one-dip 5¢ cone of ice cream or three dips for a dime and watch the monkeys. The author's parents met each other here and are pictured on the right, *c.* 1928 or early 1929. Seen from left to right are R.C. Wilson, George Harper Wells, Willis Daniel Wells, Frances Sikes Wells, and their dog, Tiny. R.C. Jones is pictured in the background.

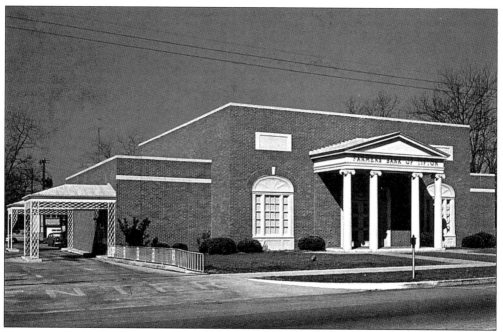

THE FARMERS BANK OF TIFTON. Located on Love Avenue, this is now the First Community Bank. The building and parking lots have replaced the homes between Second Street and Fourth Street.

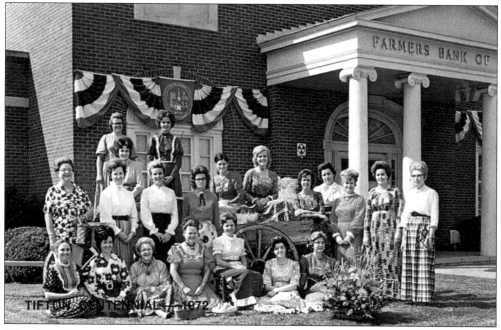

"THE CENTENNIAL BELLES" DURING TIFTON'S CENTENNIAL, 1972. Shown are the female employees of the bank in their centennial dresses. The author's mother is the first lady on the right in the picture.

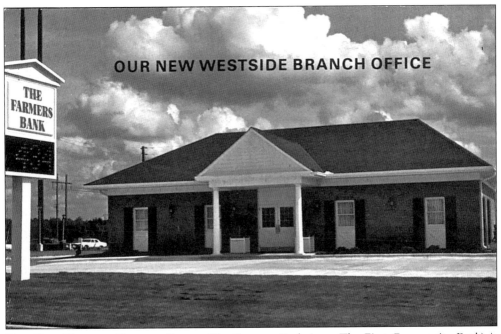

THE NEW WESTSIDE BRANCH OFFICE. The Farmers Bank (now The First Community Bank) is located on West Second Street.

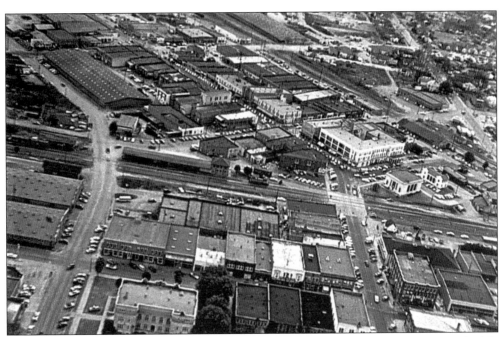

AERIAL VIEW OF DOWNTOWN TIFTON, C. 1940S. Notice the three large tobacco warehouses on the left. The courthouse is at the bottom of the picture and the Hotel Myon and Bank of Tifton are shown in the middle right side.

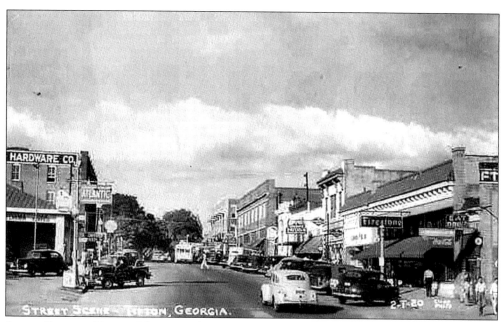

STREET SCENE IN TIFTON. This view is looking north from the railroad tracks. This is Love Avenue and south of the tracks is Main Street.

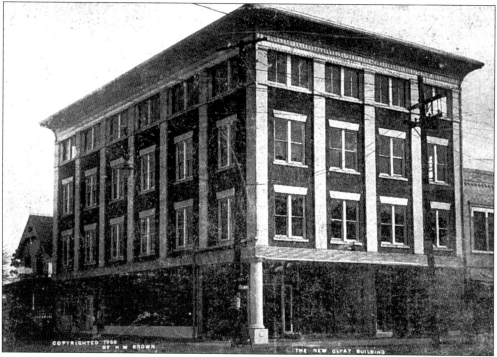

THE CLYATT BUILDING. The Clyatt Building was constructed in 1908 with four floors. The third floor served as the hospital in the 1920s. After a fire in 1929, the fourth floor was removed. Brooks Drug Store was on the corner and was a hangout for high school students. The building is now used for businesses on the ground floor and apartments on the second and third floors.

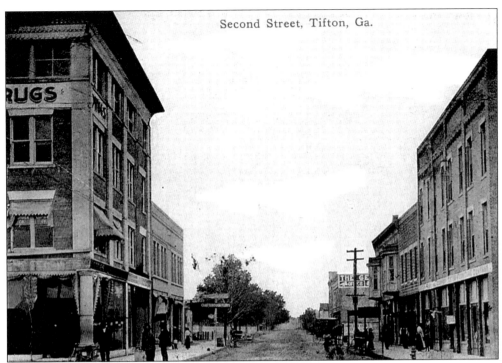

SECOND STREET. This view shows the Clyatt Building with four floors and the Tift Building on the right with three floors. One floor of the Tift Building was used as a ballroom many years ago. After a fire, the third floor was removed. All the buildings shown are still in use.

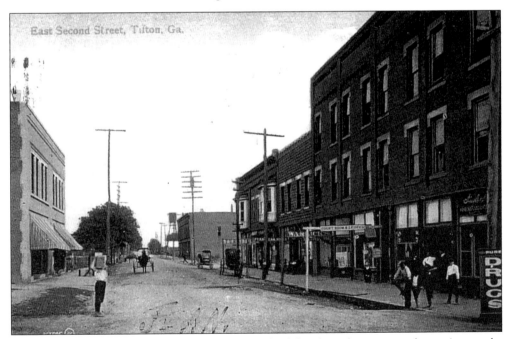

AN EARLY SCENE OF EAST SECOND STREET. On the left, where the trees are shown, is now the location of the Tift County Courthouse.

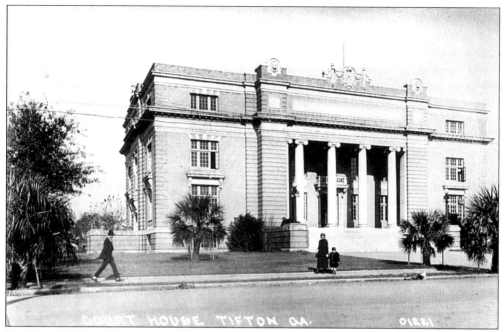

THE TIFT COUNTY COURTHOUSE. The courthouse was built in 1913 on the corner of Second Street and Tift Avenue. The building cost over $60,000.

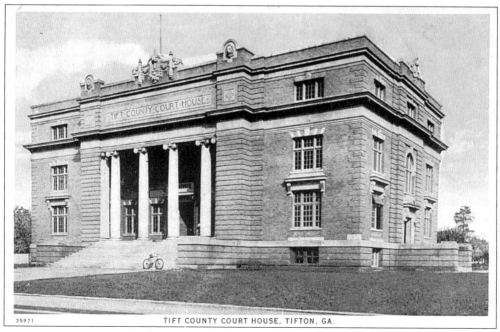

ANOTHER VIEW OF THE TIFT COUNTY COURTHOUSE. This card is postmarked November 12, 1926.

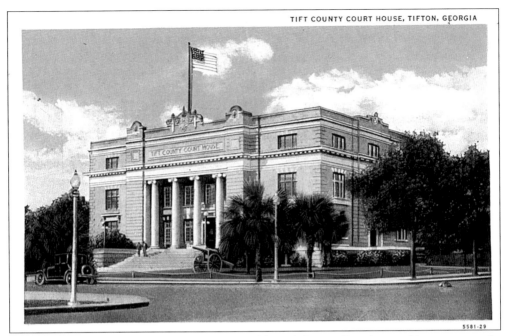

TIFT COUNTY COURTHOUSE. This is a later view of the Tift County Courthouse with a cannon on the lawn. The postcard is dated March 1936.

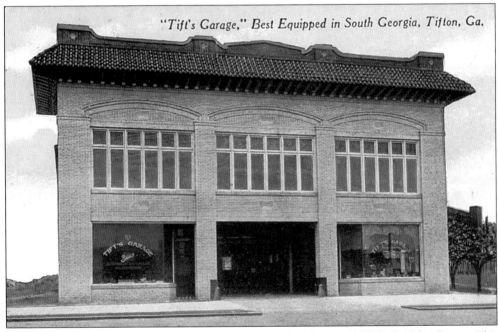

"Tift's Garage," Best Equipped in South Georgia, Tifton, Ga.

TIFT'S GARAGE. On Central Avenue, next to the railroad tracks, H.H Tift built Tift's Garage. This building was used by Barfield's Furniture Store for many years.

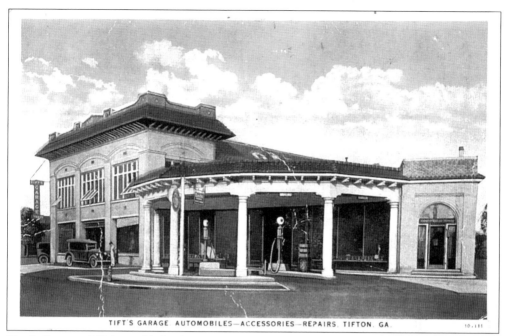

TIFT'S GARAGE AUTOMOBILES—ACCESSORIES—REPAIRS. TIFTON. GA.

TIFT'S GARAGE. Tift later added a showroom for his automobile sales and service. The small building on the right was once used as a Western Union. All of this was torn down to make way for drive-in windows for the Bank of America.

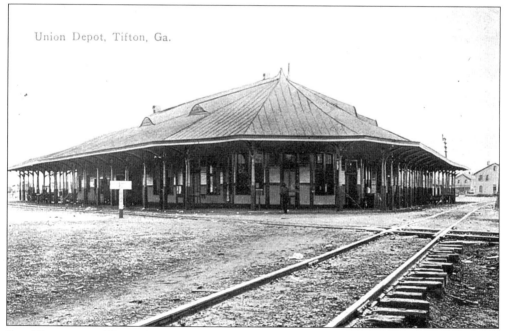

Union Depot, Tifton, Ga.

SIDE VIEW OF THE UNION DEPOT. Later known as the Southern and ACL Railroad Depot , it was located across the street from Tift's Garage.

31

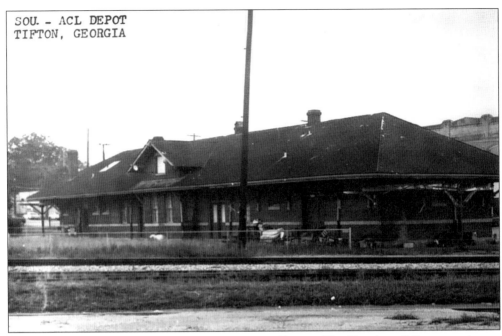

BACK VIEW OF THE SOUTHERN AND ACL RAILROAD DEPOT. The Chamber of Commerce is now located in this beautifully restored building.

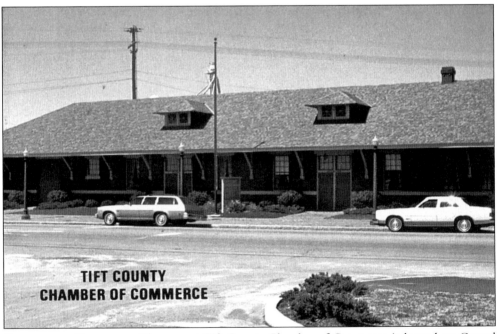

CHAMBER OF COMMERCE. The present Tift County Chamber of Commerce is located on Central Avenue in the old railroad depot shown above.

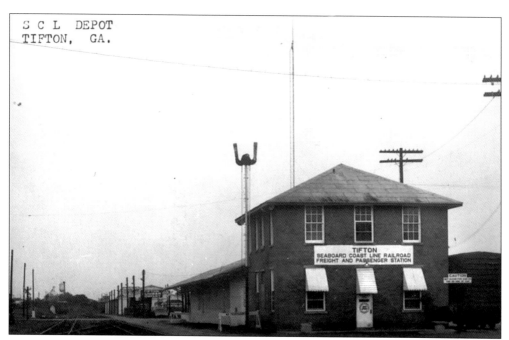

THE ATLANTIC COASTLINE DEPOT—NOW THE ATLANTIC COASTLINE ARTIST STATION. This postcard was mislabeled as the S.C.L. Depot.

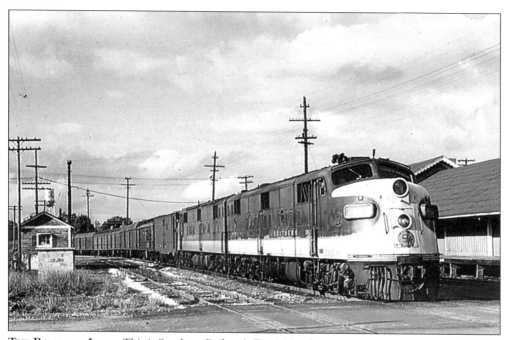

THE PONCE DE LEON. This is Southern Railway's Train Number 1 in 1958, next to a long-gone depot that is now a parking lot.

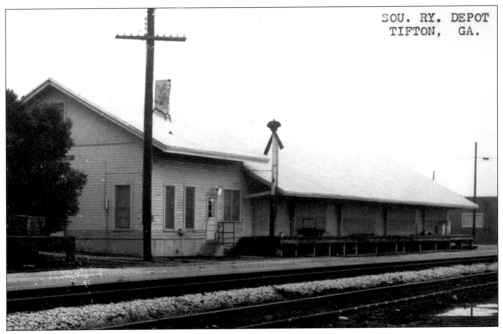

SOUTHERN RAILROAD DEPOT. The depot has been replaced with a parking lot.

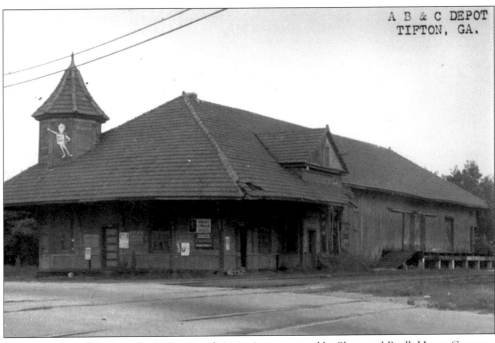

AB&C DEPOT. This depot, located on South Main, is now owned by Short and Paulk Home Center.

Three
HOMES AND
HISTORIC SITES

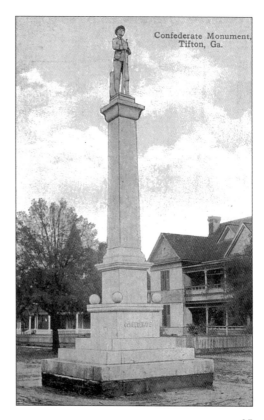

THE SOLDIER'S MONUMENT. The first location of the Soldier's Monument (Confederate Monument) was at the intersection of Love Avenue and Fourth Street. The monument was unveiled on April 26, 1910. College students used to sit on the monument base to catch a ride out to the college. The monument was later moved because so many automobiles ran into it. The Pope Home and Tift Home are also pictured.

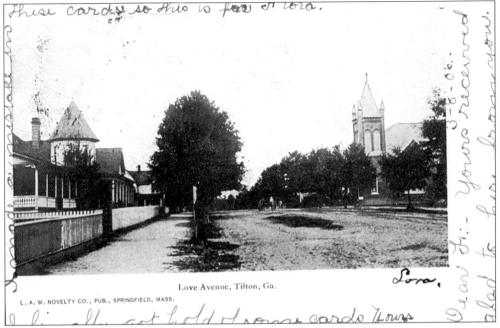

Love Avenue, Tifton, Ga.

L. A. W. NOVELTY CO., PUB., SPRINGFIELD, MASS.

PRE-1907 SCENE OF LOVE AVENUE. This postcard, sent to New York City, is dated March 8, 1906. The message is written around the picture because only the address was allowed on the other side of the postcard. Love Avenue was named for Tifton's first mayor, Willard Herschel Love.

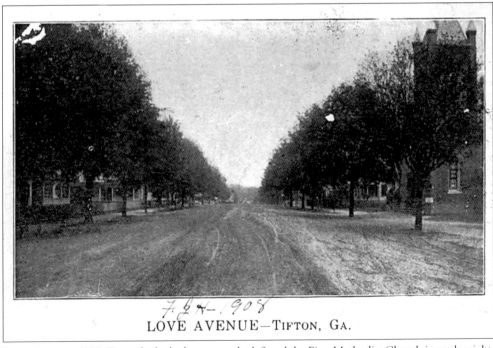

LOVE AVENUE—TIFTON, GA.

LOVE AVENUE, 1908. Trees shade the homes on the left and the First Methodist Church is on the right.

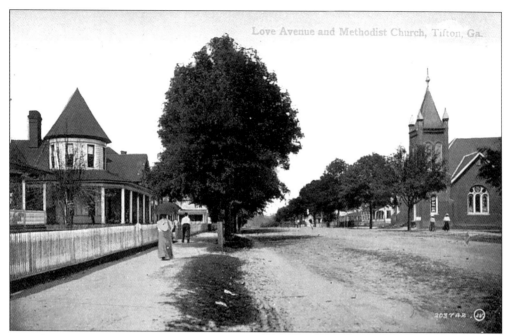

LOVE AVENUE IN 1908. Love Avenue was originally lined with beautiful homes but is now commercial. The First Methodist Church on the right is now the Tifton Museum of Arts and Heritage.

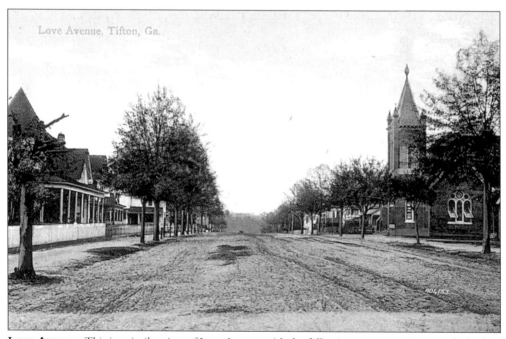

LOVE AVENUE. This is a similar view of Love Avenue with the following message written on the back of the card: "I spent three days in this town." The card was never mailed.

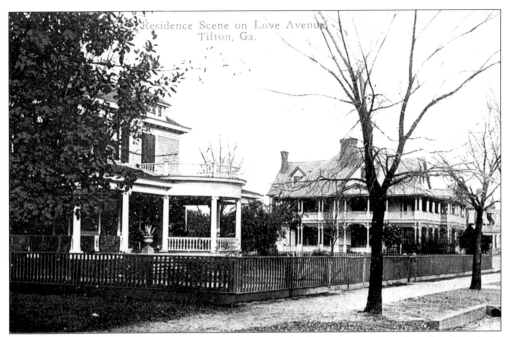

RESIDENCE SCENE ON LOVE AVENUE. The first house was built by W.W. Banks and was later bought by The First Baptist Church and used for the Pastorium for many years. Next was the home of Dr. W.H. Hendricks and family, which was built by Orville Tift. These two homes have been replaced by the First Baptist Church additions. The E.A. Buck home is the third one shown.

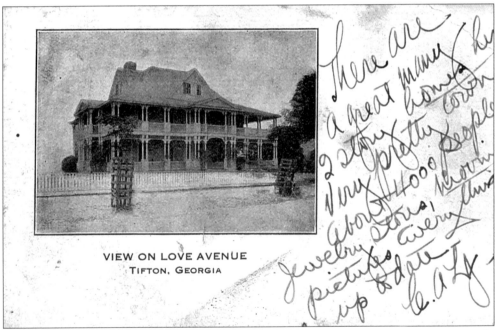

PRE-1907 POSTCARD SHOWING THE ORVILLE TIFT HOME (LATER HENDRICKS). The message reads, "There are a great many 2 story homes here, very pretty town. About 4000 people—Jewelry stores, moving pictures—everything up to date. –C.A.L.j." It is postmarked September 21, 1908.

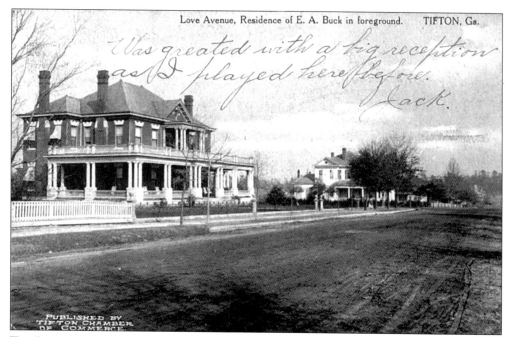

Was greeted with a big reception as I played here before. Jack.

THE LOVE AVENUE HOME OF E.A. BUCK (IN THE FOREGROUND.) The next home was that of the Enoch Piercel Bowen Sr. family. It was originally located on the corner of Love Avenue and Fourth Street but was moved to the corner of Love Avenue and Sixth Street so that the First Baptist Church could be built on that lot. The home was moved again by the "Moose" Cox family and is now located on Wilson Avenue.

BOWEN-DONALDSON HOME FOR FUNERALS. The E.A. Buck home is now the Bowen-Donaldson Home for Funerals. The funeral home was established in 1888. It is located on the corner of Love Avenue and Sixth Street.

BOWEN-DONALDSON HOME FOR FUNERALS. This is a later view of the Bowen-Donaldson Home for Funerals, with a chapel added on the right side.

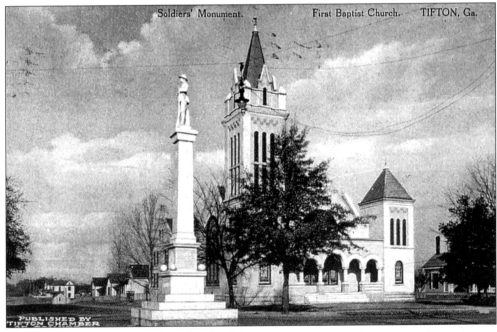

CONFEDERATE MONUMENT. This is the Confederate Monument at the intersection of Love Avenue and Fourth Street. The First Baptist Church is in the background. All of the surroundings have been moved or torn down.

Tifton
Georgia

THE EDMUND HARDING TIFT HOME. This home is now owned by Coldwell Banker and Webb & Sims Realty and has been restored and furnished to its original beauty. It was once owned by the Frank Corry family. The home next door was the home of Mrs. Susie T. Moore. Mrs. Moore was Georgia's first female state senator. It is now the office of the Buckley Law Firm.

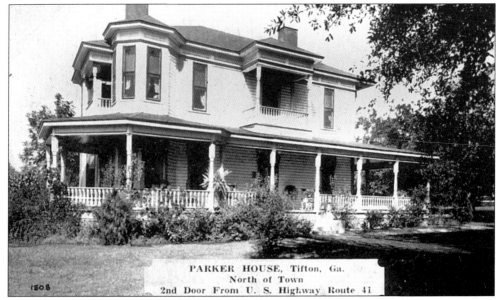

PARKER HOUSE, Tifton, Ga.
North of Town
2nd Door From U. S. Highway Route 41

THE PARKER HOUSE. The Parker House is still located on North Central Avenue and is now divided into apartments.

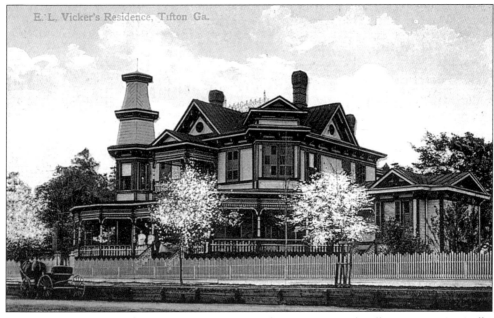

THE E.L. VICKERS HOME. It still exists on the corner of Fourth Street and College Avenue. Originally, all streets in Tifton were numbered and all avenues were named. All even numbers were north of the railroad tracks and all odd numbers were located south of the railroad tracks. Therefore, Second, Fourth, Sixth, etc. Streets are on the north side and First, Third, Fifth, etc. Streets are on the south side. Avenues are named Tift, Love, Central, Park, Ridge, Wilson, College, Murray, Hall, etc. Therefore, if you live at 1801 Wilson Avenue, you live on the corner of West Eighteenth Street and Wilson Avenue on the right going north, so you would live in the northwest side of town. Central Avenue divides the town by east and west.

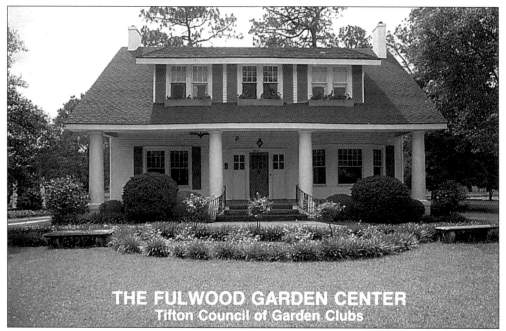

FULWOOD GARDEN CENTER. Originally the Paul D. Fulwood Sr. home, this building is now the Fulwood Garden Center. When the home was built, it was considered to be out in the country. It is now surrounded by many other homes and businesses and is located on the curve of Twelfth Street and North Highway 41.

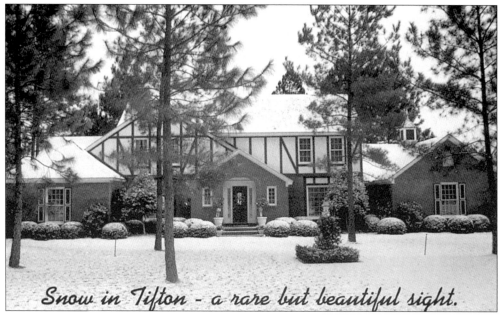

SNOW IN TIFTON. This is a rare but beautiful sight. The back of the card reads, "Snow in Tifton is rare, but it compliments the natural beauty of our South Georgia landscape." Tifton had several inches of snow on February 23, 1989 and this card was on a 1991 calendar. The home pictured is that of Amelia and Howard Dorsett. Mr. Dorsett is a former president of The First Community Bank.

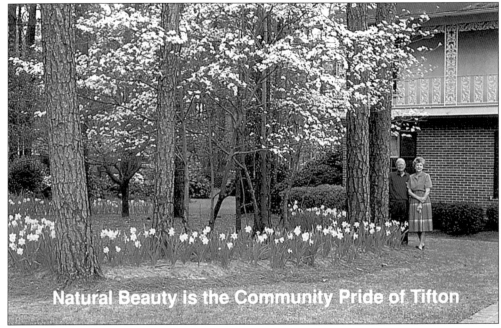

Natural Beauty is the Community Pride of Tifton

THE JOHN HENRY DAVIS HOME ON WEST TWENTIETH STREET. Mrs. Davis and the late Mr. Davis are shown with their daffodils and dogwood trees in bloom. Mr. Davis was a former president of The Farmers Bank of Tifton.

OAKFIELD. This was the residence of the late Dr. and Mrs. George A. Wright. The home is now owned by Suzanne and Dudley Click.

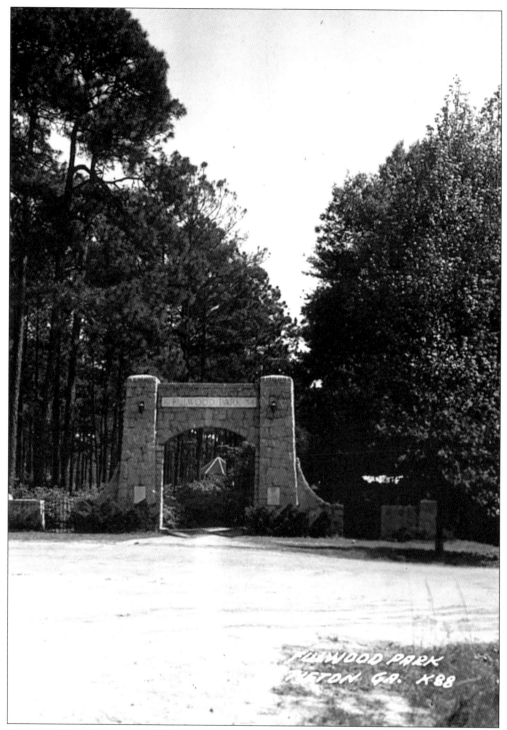

FULWOOD PARK. Located on Tift Avenue between Eighth Street and Twelfth Street is Fulwood Park. The land for the park was donated by Tifton's founder, Mr. H.H. Tift, in honor of his friend Mr. P.D. Fulwood. Tift Avenue was not paved when this postcard was produced.

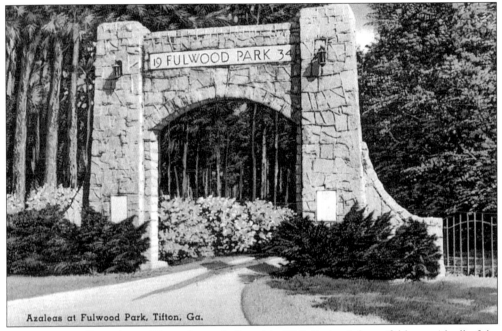

Azaleas at Fulwood Park, Tifton, Ga.

THE FULWOOD PARK ARCH. The arch was dedicated in 1934. Spring is beautiful here with all of the azaleas in bloom. The park is now the site for the Annual Love Affair.

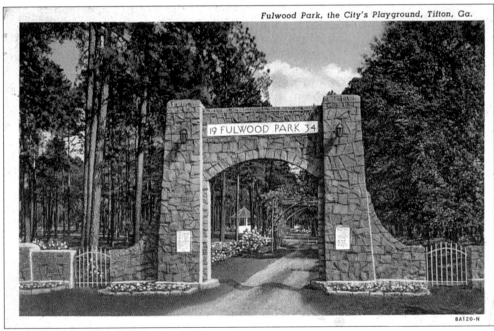

Fulwood Park, the City's Playground, Tifton, Ga.

8A120-N

THE BANDSTAND. In this view, you can see the bandstand in Fulwood Park. Also, note the canopy with blooming flowers over the park road. Since automobiles are larger now, the entrance is closed and new entrances are on each side of the arch. The bandstand no longer exists. There are restrooms in that area now.

THE LOVE AFFAIR. Tifton's fine arts festival is held every first weekend in May. The affair was originally held on Love Avenue but because of its growth, more room was needed and it was moved to Fulwood Park in 1989.

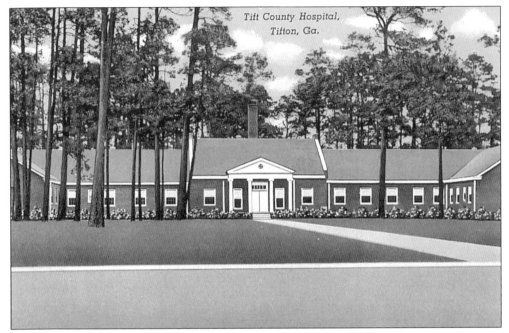

TIFT COUNTY HOSPITAL. The hospital was opened on December 1, 1940 on West Twelfth Street. The building faces Fulwood Park and is now the Tift County Health Department.

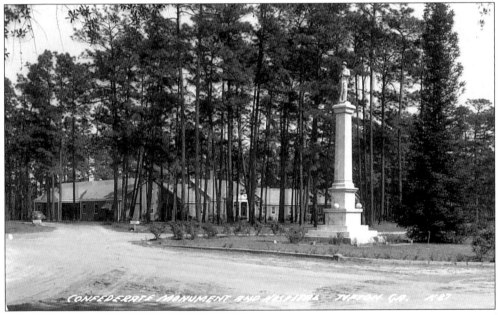

SECOND LOCATION OF CONFEDERATE MONUMENT. This photograph shows the second location of the Confederate Monument at the intersection of Twelfth Street and Tift Avenue. The monument was moved for a third time to Fulwood Park, too close to the street. Fearing someone would run into the monument, it was then moved a fourth time further into the park. Tift County Hospital is in the background.

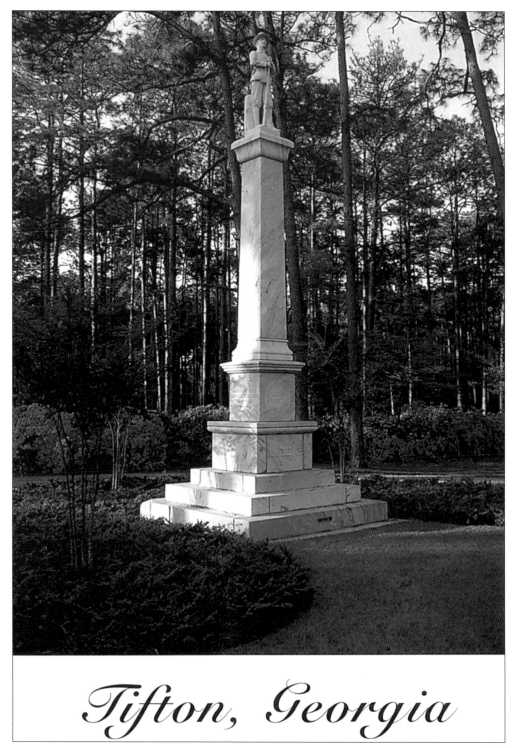

Tifton, Georgia

FOURTH LOCATION OF THE CONFEDERATE MONUMENT. Hopefully, this will be the final resting place for the Confederate Monument—inside Fulwood Park.

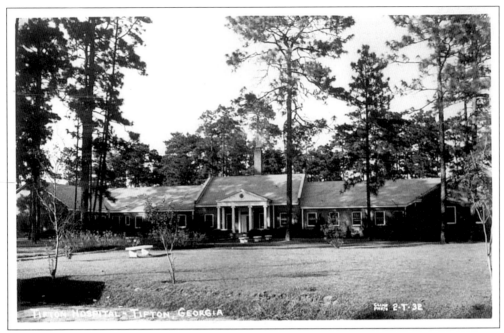

TIFTON HOSPITAL. Located on West Twelfth Street, the hospital is currently undergoing its second reconstruction.

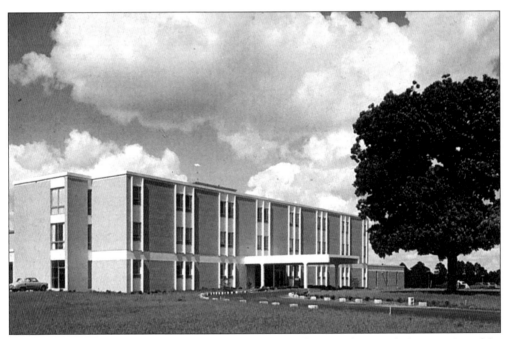

TIFT REGIONAL HOSPITAL. Tift General Hospital is now Tift Regional Hospital. Construction of the building shown was completed in the fall of 1965. It is located on East Eighteenth Street and is now at least five times larger than the building shown.

Four

SCHOOLS AND CHURCHES

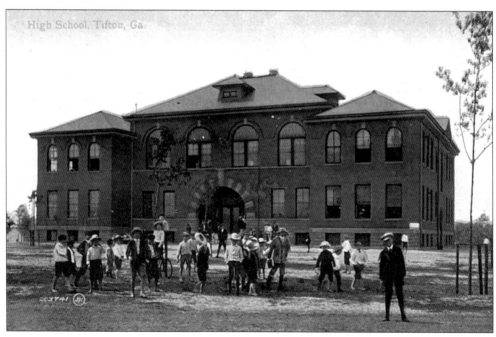

TIFTON HIGH SCHOOL. A new high school was built on North Park Avenue in 1906. It later became Annie Belle Clark Elementary School. It was demolished and replaced by the post office in 1964. A new street named John Howard Way was cut through the center of the block. The post office is on one side of this street and a bank is on the other.

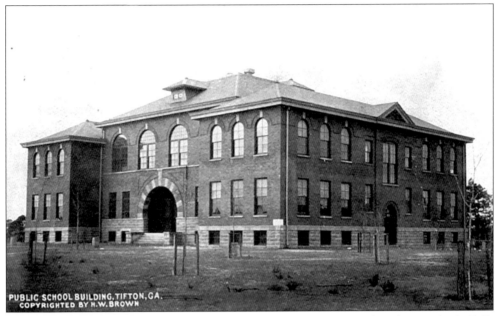

PRE-1907 POSTCARD OF THE PUBLIC SCHOOL BUILDING IN TIFTON. It later became Annie Belle Clark Elementary School. This card is postmarked April 26, 1908.

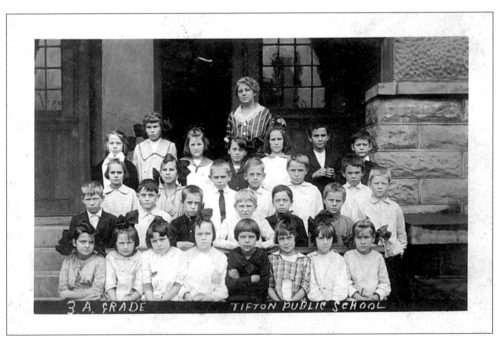

CLASS OF 3A AT TIFTON PUBLIC SCHOOL. This building later became Annie Belle Clark Elementary School on North Park Avenue. On the back of the card is written in pencil, "Britt Family, Tifton, Ga." The Britt family was a very prominent family in Tifton at the time of this postcard. There were seven daughters and one son. The family no longer resides in Tifton.

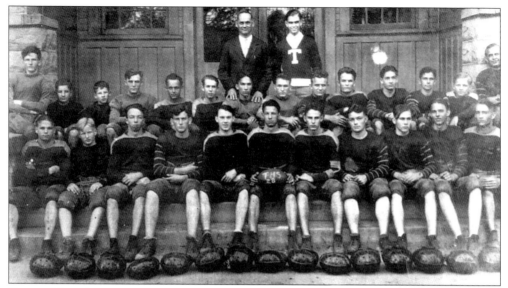

TIFTON HIGH SCHOOL BLUE DEVILS FOOTBALL TEAM, 1928. Coach G.O. Bailey later became the school principal, and then became the superintendent of Tifton schools. This picture was taken in front of the old high school. A new high school was built in 1917, but the school shown was closer to the football field.

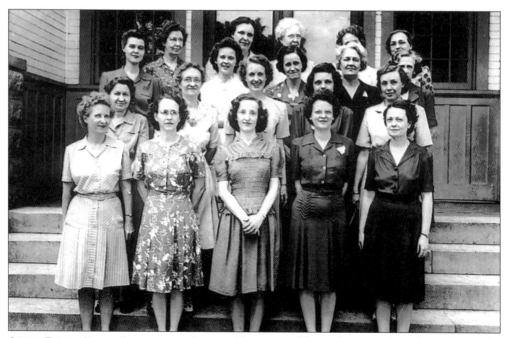

ANNIE BELLE CLARK ELEMENTARY SCHOOL TEACHERS. The teachers are pictured standing on the steps, *c.* 1940s. Seen from left to right are (first row) Miss White, Eunice Sperlin, Thena Peele, Maude Myrick, and Sara Chandler Doss; (second row) Mrs. G.O. Bailey, Lula Mae Morgan, Elizabeth Yow (principal), unidentified, and Grace Patton; (third row) Sara Rowan, Sara Doss Barr, Mary Neal Hubbard, Alma Mathis, and Mrs. Oscar Bowen; (fourth row) Louise Sheeler, Clara Wells, Olive King, Ann Bowen, and Marie Turk.

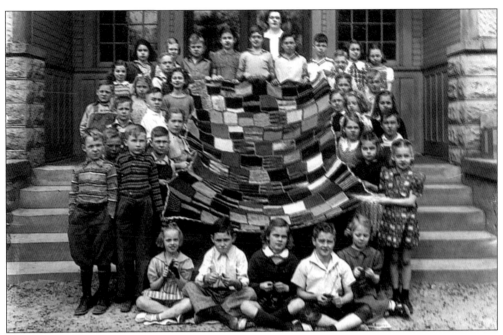

ANNIE BELLE CLARK ELEMENTARY SCHOOL THIRD-GRADE CLASS. The third-grade students of the 1941–1942 school year are pictured here. The children are holding a handmade blanket they knitted to give to the Red Cross. Squares for the blanket were knitted using 60 penny nails and were put together by their teacher, Mary Phillips.

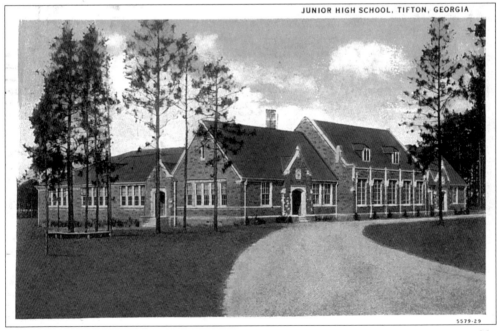

JUNIOR HIGH SCHOOL, TIFTON. This card is postmarked March 18, 1931 and reads, "Costing over fifty thousand dollars." The school is located on West Twelfth Street and was renamed Annie Belle Clark Elementary School when the school on North Park Avenue was torn down.

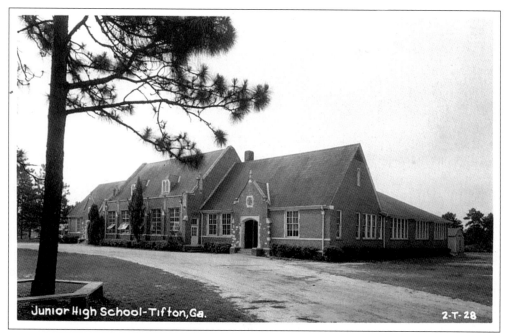

Junior High School-Tifton,Ga.

2-T-28

JUNIOR HIGH SCHOOL, TIFTON. This is another view of the former Junior High School on West Twelfth Street. Built in 1929, it was almost destroyed by fire in 1930. It is now Annie Belle Clark Elementary School, but will become a pre-school center when a new facility for the elementary school is completed.

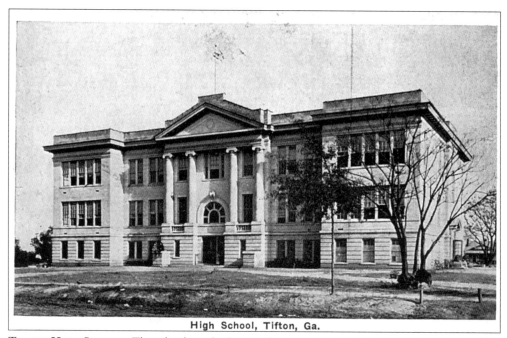

High School, Tifton, Ga.

TIFTON HIGH SCHOOL. The school was built on Tift Avenue in 1917. The grounds were beautified by the Twentieth Century Library Club in 1921. The building now serves as the Tift County Administration Building.

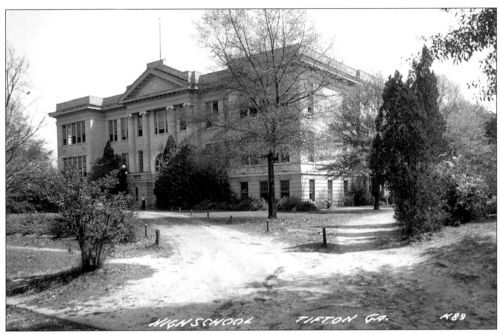

TIFTON HIGH SCHOOL. The school is pictured here after the beautification. The Twentieth Century Library Club set out 112 shrubs, 8 shade trees, and 2 oak trees near the curb in 1921.

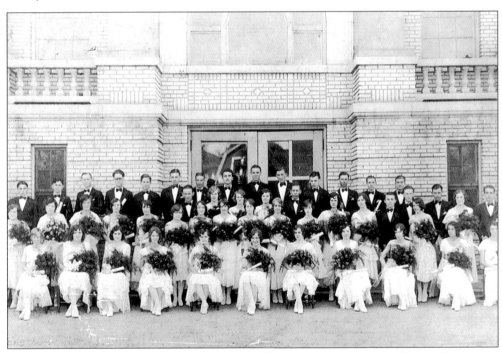

TIFTON HIGH SCHOOL GRADUATING CLASS, 1930. The class is posed in front of Tifton High School on Tift Avenue. Some of the graduates were Bessie Mae Marchant, Maude Burns Smith, Rosalie Lennon, Imogene Dinsmore, Fay Sikes, Eunice Spurlin (the author's third-grade teacher), Robert Earl Martin, Claude Connor, "Moose" Cox, Orman Mitchell, and Dreyfus Harris.

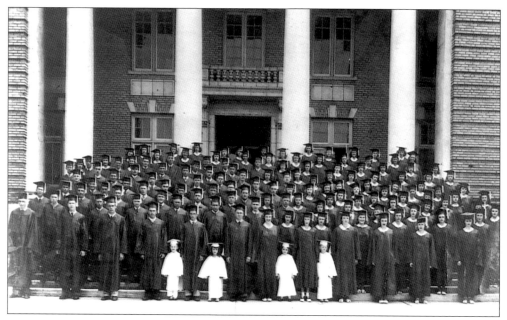

TIFTON HIGH SCHOOL GRADUATING CLASS, 1949. The author's graduating class is pictured in front of the Tift County Courthouse. The author is almost dead center on the second row.

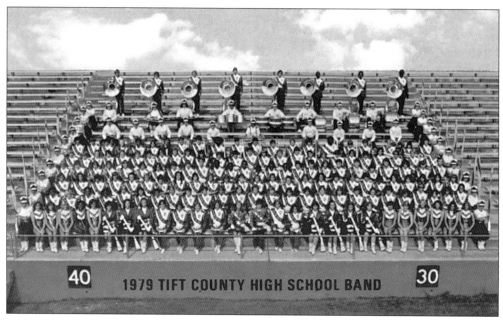

THE 1979 TIFT COUNTY HIGH SCHOOL BAND. In the early 1960s, the Tifton-Tift County schools were consolidated. The band is shown at the football stadium on West Eighth Street. Bill Belcher was the band director.

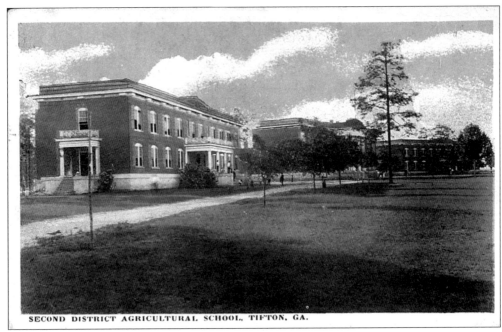

SECOND DISTRICT AGRICULTURAL SCHOOL, TIFTON, GA.

SECOND DISTRICT AGRICULTURAL SCHOOL. The school operated from 1908 until 1925. Capt. H.H. Tift donated 315 acres of land and the citizens of Tifton and Tift County, rich and poor, gave generously to raise money to defray one-half the cost of erecting the three original buildings shown above.

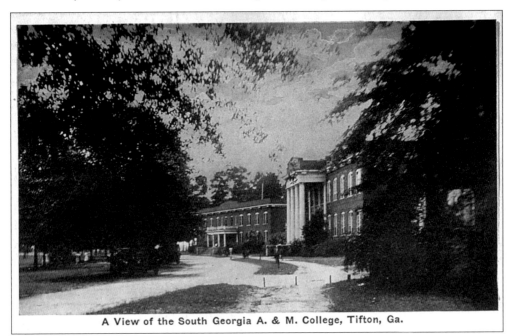

A View of the South Georgia A. & M. College, Tifton, Ga.

SOUTH GEORGIA A&M COLLEGE. The Agricultural School became the South Georgia A&M College in 1925. In 1929, the college became Georgia State College for Men until 1933, when it was renamed Abraham Baldwin Agricultural College. Tift County citizens were upset when the college was changed from a four-year to two-year college in 1933.

Eta Tau Epsilon

WILL SPONSOR THE KIND OF

DANCE

THAT COMES "ONCE IN A BLUE MOON"

Wednesday Night, March 16th

COLLEGE GYMNASIUM : TIFTON, GA.

MUSIC BY

—AND—

BLUE STEELE His Recording Orchestra

SCRIPT $1.50 10 TIL—?

COLLEGE DANCE, 1932. This is an interesting "penny" postcard announcing a dance at the college gymnasium at the Georgia State College for Men. The card is postmarked March 10, 1932.

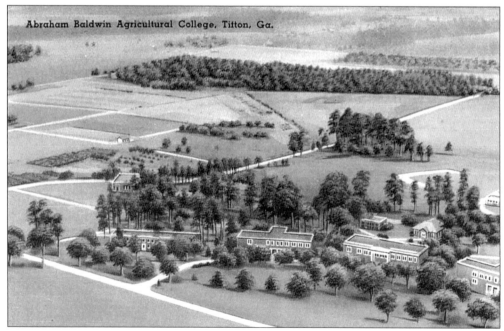

AN EARLY AERIAL VIEW OF ABRAHAM BALDWIN AGRICULTURAL COLLEGE (ABAC). Weltner Hall and the three original buildings are shown. Weltner Hall was named for the chancellor of the University System of Georgia.

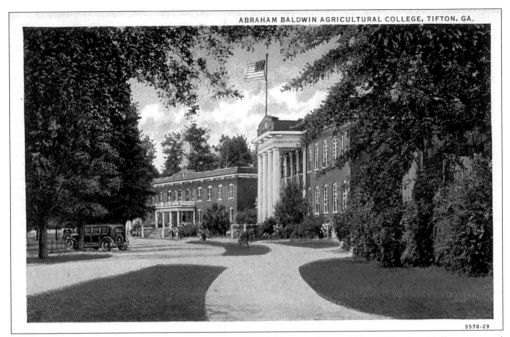

A VIEW OF HERRING HALL AND TIFT HALL AT ABAC FROM LEWIS HALL. Herring Hall was named for John Lewis Herring (1866–1923). On September 14, 1914, he established *The Daily Tifton Gazette.*

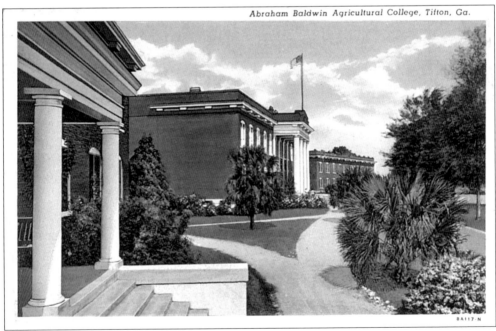

A VIEW OF TIFT HALL AND LEWIS HALL AT ABAC FROM HERRING HALL. Lewis Hall was named for Mr. S.L. Lewis. Mr. Lewis was president (1910–1912) when the college was the Second District A&M School.

60

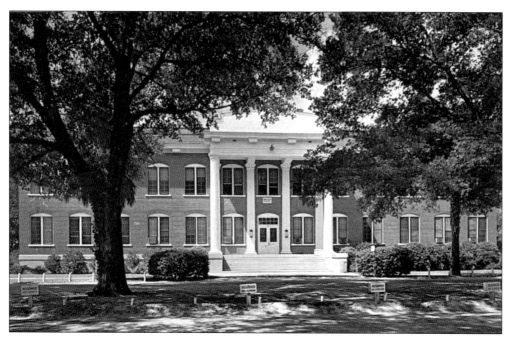

TIFT HALL, THE ADMINISTRATION BUILDING AT ABAC. Tift Hall was named for Capt. H.H. Tift, the founder of Tifton and the donator of land for the college.

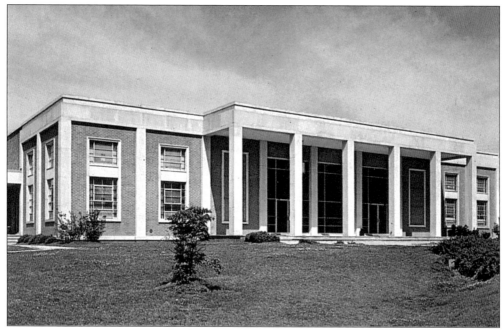

ABAC'S DONALDSON DINING HALL. The building was named for former ABAC President George P. Donaldson. Mr. Donaldson served the college in different capacities for 40 years.

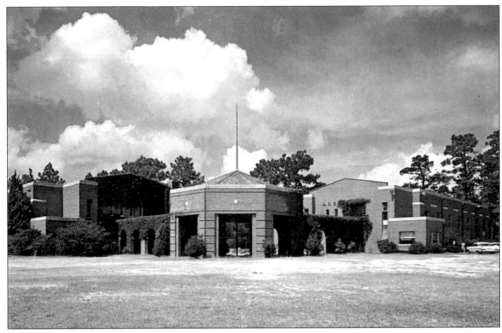

THE THRASH GYMNASIUM AND HOWARD AUDITORIUM, BUILT 1939–1940. Howard Auditorium, named in honor of Registrar Evamae Howard, is currently being renovated. Thrash Gymnasium was named in honor of Prof. Joseph M. Thrash.

THE CURRENT GYMNASIUM AT ABAC. The gymnasium was named for Coach Bruce V. Gressette, who was the basketball coach from 1945 to 1963. The building also hosts high school tournaments and graduation ceremonies.

CRESWELL HALL. This building was constructed as a women's dormitory at ABAC, and named for Edith Creswell, Dean of Women and Professor of Economics during the 1930s.

GRIFFIN RURAL LIFE BUILDING. This building was named for Ernest H. "Pat" Griffin, father of Georgia governor Marvin Griffin (1955–1959).

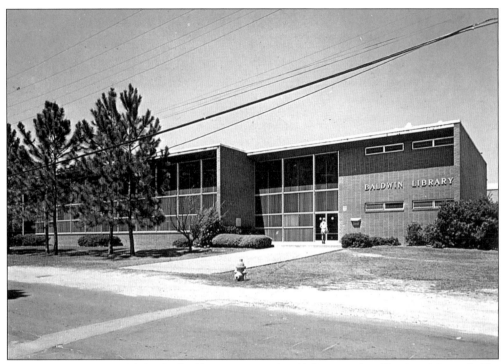

BALDWIN LIBRARY AT ABAC. This building, constructed in 1961, was replaced by a much larger facility in 1990. It now serves as the Music Building and is used by the band and chorus.

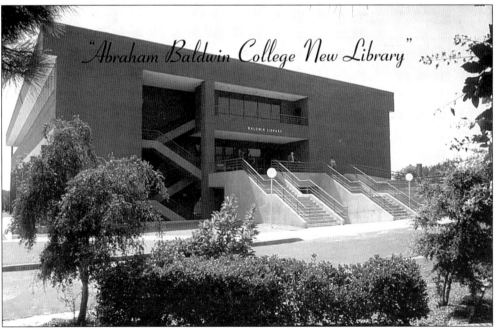

ABRAHAM BALDWIN COLLEGE NEW LIBRARY. This three-story, 42,000-square-foot facility opened in 1990. It is now known as the Carlton Center. It was named after O.D. Carlton, longtime benefactor of the college.

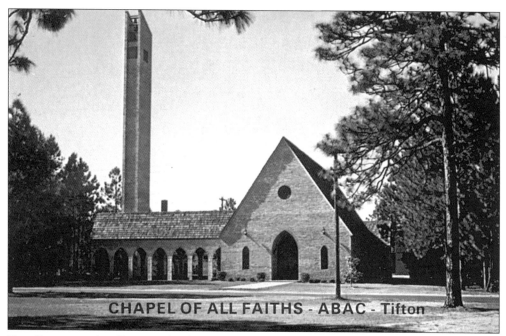

THE CHAPEL OF ALL FAITHS. The chapel was dedicated on November 21, 1974. Miss America 1975, Shirley Cothran, was at the dedication. The chapel was a dream come true for Dr. J. Clyde Driggers, the president of ABAC.at the time.

THE FIRST AND MAIN BUILDINGS AT THE COLLEGE. This is a later view of the buildings, which were constructed in 1906–1907. Seen from left to right are Herring Hall, Tift Hall, and Lewis Hall.

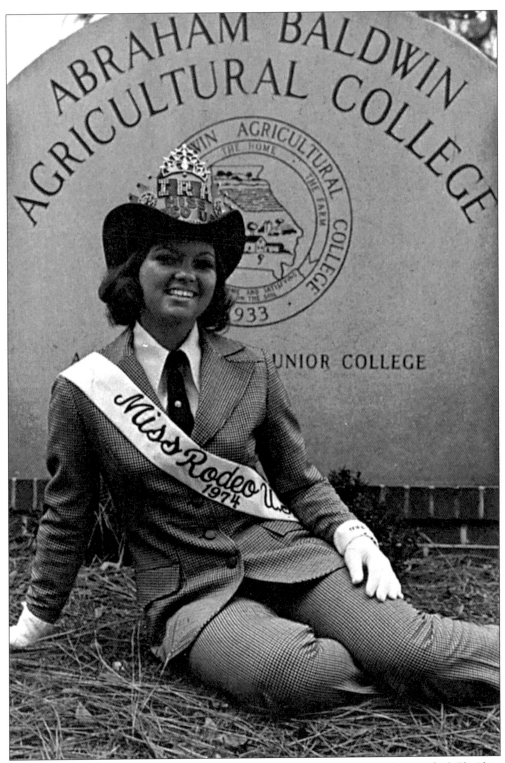

MISS RODEO QUEEN USA, 1974. Terry Jo Langford was an ABAC sophomore from Oxford, Florida.

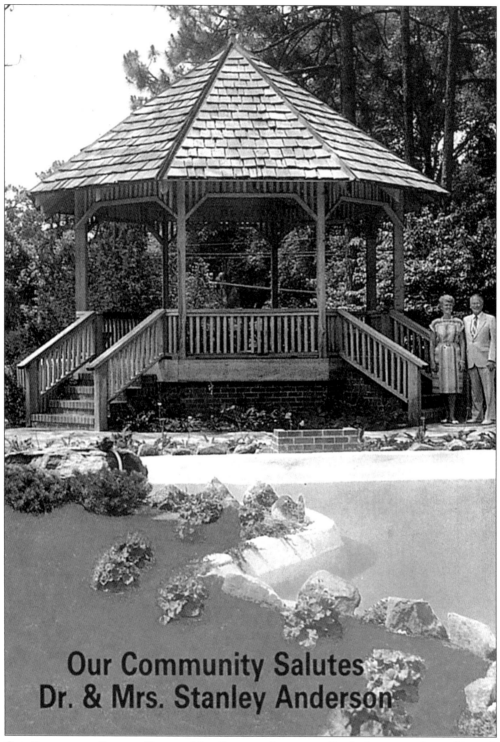

Our Community Salutes
Dr. & Mrs. Stanley Anderson

OUR COMMUNITY SALUTES DR. AND MRS. STANLEY ANDERSON. Dr. Anderson was the president of ABAC from 1975 to 1985. Dr. Anderson is best known for his campus beautification program.

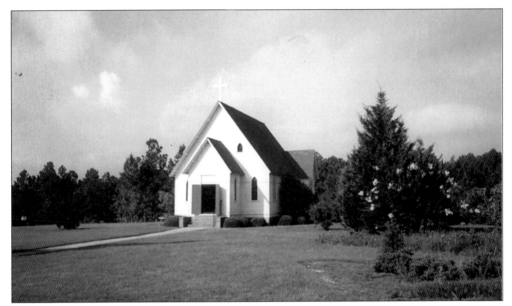

ST. ANNE'S EPISCOPAL CHURCH. St. Anne's, built in 1898, was originally located on the corner of North Central Avenue and West Fourth Street. It is now known as "Little St. Anne's" after the move to the block of Twenty-fourth Street between Love Avenue and North Central Avenue. Within this block, a much larger St. Anne's was built along with a parish hall and a Sunday school/administration building.

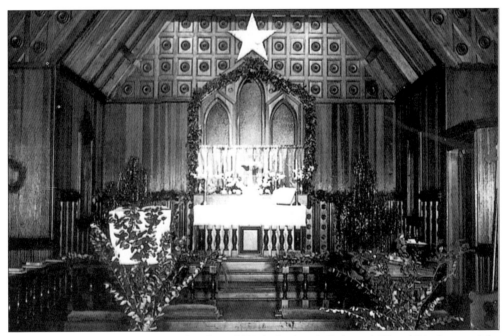

ST. ANNE'S EPISCOPAL CHURCH. The altar of "Little St. Anne's Episcopal Church" is decorated for a Christmas service many years ago. Some of the woodwork in the interior was carved underwater. The building remains almost exactly as it was constructed but is now in a different location. On January 26, 1902, St. Anne's was consecrated by Bishop C.K. Nelson. It is the second-oldest church building in Tifton.

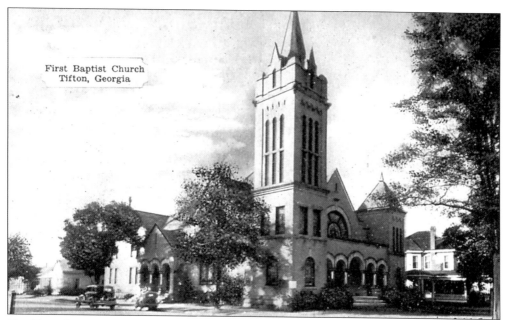

THE FIRST BAPTIST CHURCH ON LOVE AVENUE. The cornerstone for this church was laid on October 31, 1906. This building became the church chapel when the new sanctuary was built.

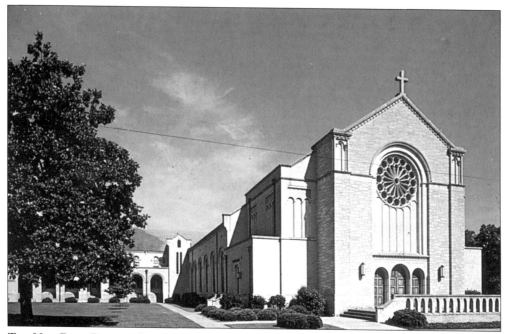

THE NEW FIRST BAPTIST CHURCH SANCTUARY. The sanctuary was dedicated on Easter Sunday, April 2, 1961. The church motto is, "The Church Built on Love" (Love Avenue).

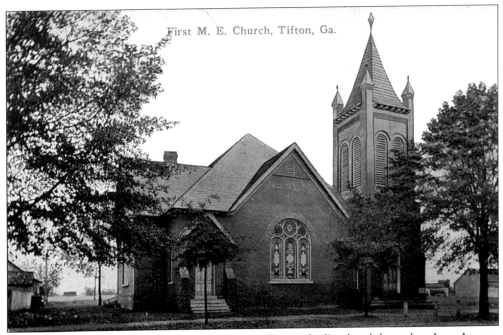

First M. E. Church, Tifton, Ga.

THE FIRST M.E. CHURCH IN TIFTON. This was the first Methodist church located on Love Avenue. The building is now The Tifton Museum of Arts and Heritage.

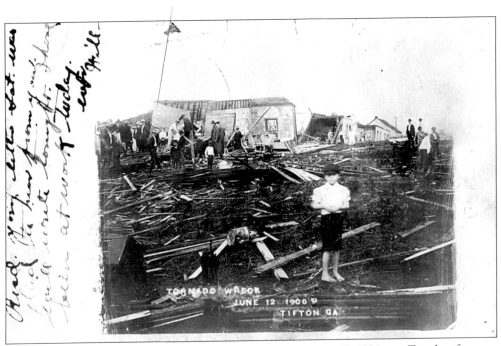

TORNADO WRECK
JUNE 12 1906
TIFTON GA

FIRST PRESBYTERIAN CHURCH, DEMOLISHED BY A STORM. On June 12, 1906, on a Tuesday afternoon at about 1:15 p.m., a severe wind, scarcely attaining the force of a cyclone, struck Tifton. The First Presbyterian Church was demolished. The church building was located at 210 North Central Avenue. Remains of the building are shown.

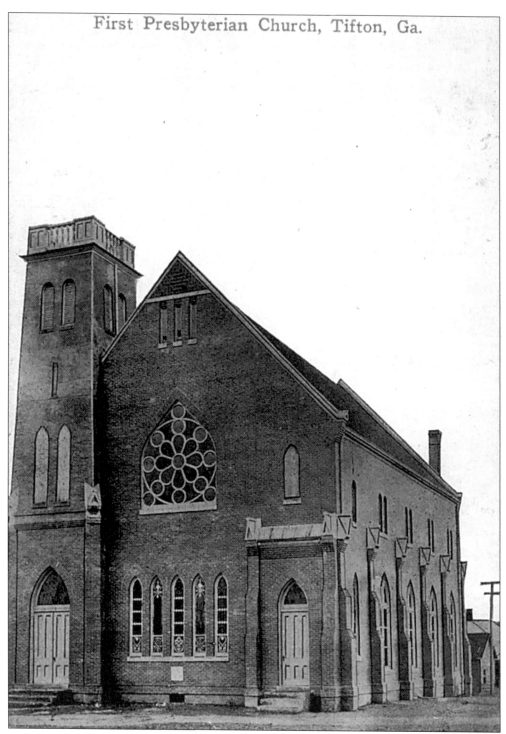

THE FIRST PRESBYTERIAN CHURCH. This building was originally The First Baptist Church. The Presbyterians bought this building on North Park when the new First Baptist Church was built in 1906. The bell tower and the second floor were removed and it is still The First Presbyterian Church.

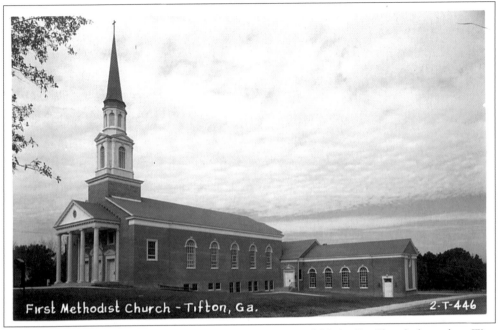

First Methodist Church - Tifton, Ga. 2-T-446

FIRST UNITED METHODIST CHURCH. The "new" First United Methodist Church, located on West Twelfth Street, held its first service on August 24, 1952. Rev. John E. Wilson delivered the first sermon; Rev. William C. Beasley is the current pastor.

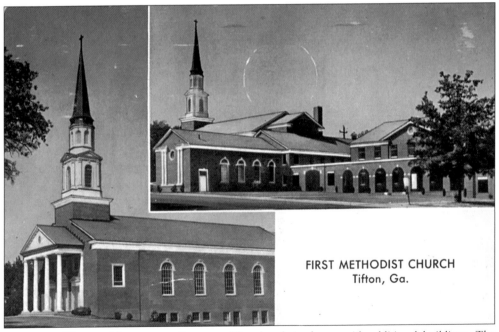

FIRST METHODIST CHURCH
Tifton, Ga.

THE FIRST UNITED METHODIST CHURCH. The church is shown with additional buildings. The congregation numbers around 2,000. This is the "mother church" for several other Methodist churches in Tifton.

TRINITY UNITED METHODIST CHURCH. This church is located at 603 Belmont Avenue.

THE NORTHSIDE BAPTIST CHURCH. This church is located on the corner of North Ridge Avenue and Twentieth Street. Because of its growth, the congregation is in the process of building a new facility in another location.

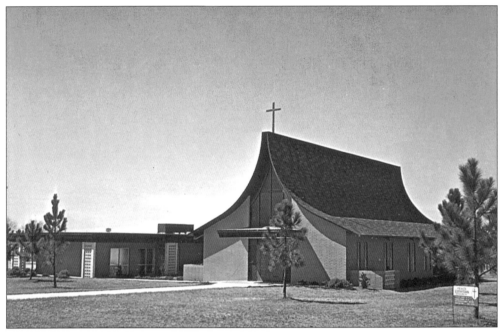

PEACE LUTHERAN CHURCH. The church is located on the corner of Tennessee and Florida Avenues.

THE ICE MAN. John Thomas Carmichael was known as "the ice man." The picture was taken close to The First Baptist Church and Lankford Manor on the corner of Love Avenue and Fourth Street.

74

Five
DINING AND LODGING

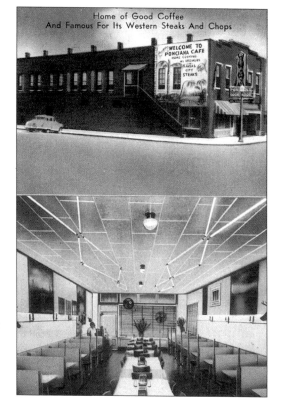

PONCIANA CAFÉ. "Home of Good Coffee and Famous for Its Western Steaks and Chops." Built as the Shepherd-Manard building, Paul Vanes leased this building in 1931 and said, "(I) will put in a first class restaurant." Men, including my dad, met here each morning for coffee and a "bull session." The building now houses Central Jewelers at 301 Main Street.

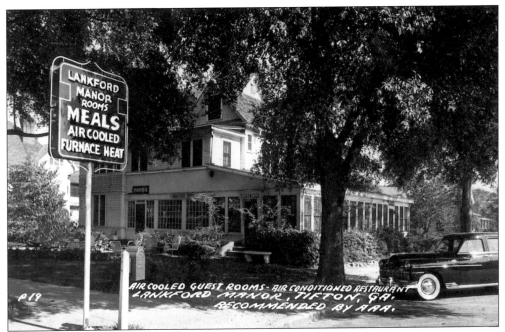

THE LANKFORD MANOR. Mr. John Pope built this home in 1892. The Lankford Family bought it in 1934 and it became a wonderful place to eat for local people and for weary travelers needing a place to eat and sleep.

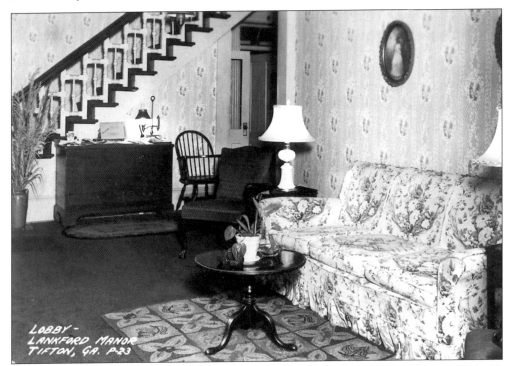

THE LANKFORD MANOR. This postcard shows the lobby of the Lankford Manor, which was filled with many beautiful antiques and accessories.

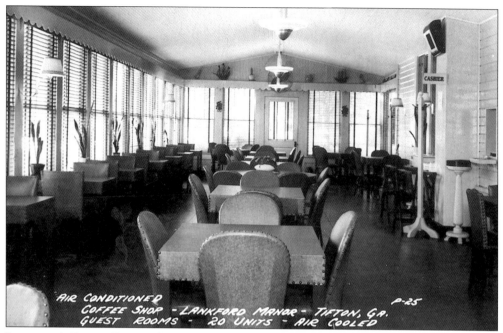

LANKFORD'S DINING ROOM. This view is of the inside of the Lankford's dining room. In its day, it was recommended by Duncan Hines and the AAA Motor Club.

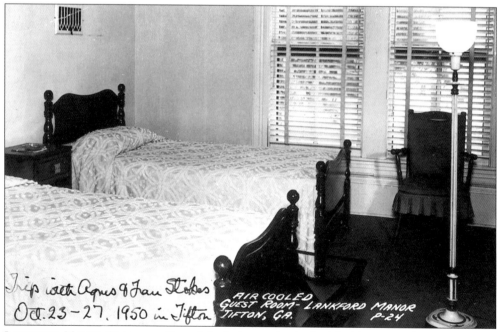

LANKFORD MANOR BEDROOM. One of the bedrooms in the Lankford Manor is the subject of this photo. The manor had 20 bedrooms and bathrooms that were rented to travelers on the way to Florida or back home.

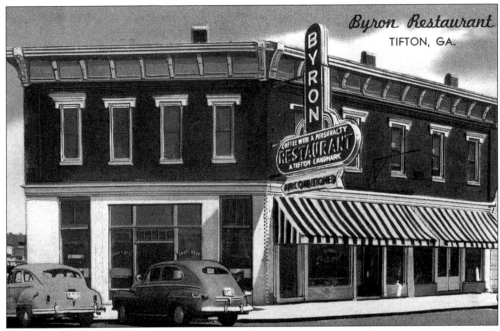

THE BYRON RESTAURANT. This restaurant offered good food and fine service at reasonable prices on Main Street. To the left was the Cigar Store where one could stop for a beer, cigars, cigarettes, and magazines. Upstairs were rooms for rent. The building is now La Cabana II, "A Fine Mexican Restaurant."

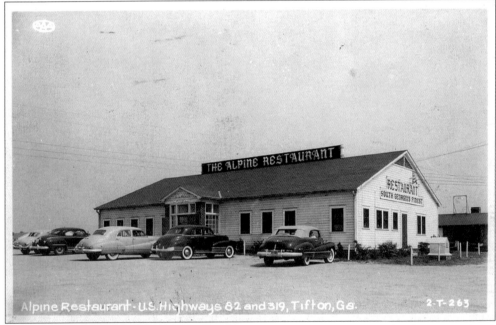

THE ALPINE RESTAURANT. People would drive from many miles away to eat at the Alpine in its day. It was located at the intersection of US 82 and US 319. When it was torn down some years ago, the Western Sizzlin' was built in the area.

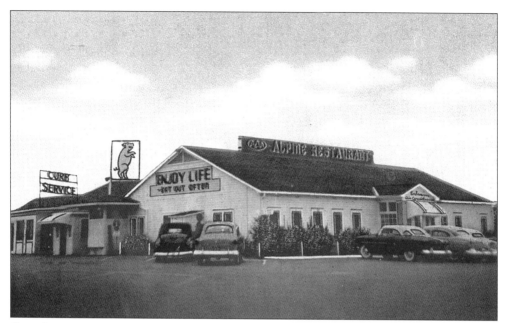

CURB SERVICE AT THE ALPINE RESTAURANT. The restaurant's logo was, "Enjoy Life, Eat Out Often." With curb service, it was easy to order a hamburger, fries, and a Coke!

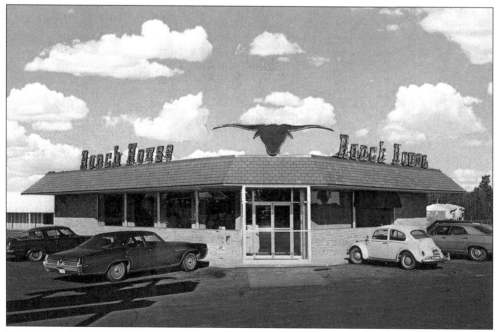

THE RANCH HOUSE RESTAURANT. Located on West Second Street near I-75, the Ranch House boasted "Always Fine Food." A Mexican Restaurant is located there now.

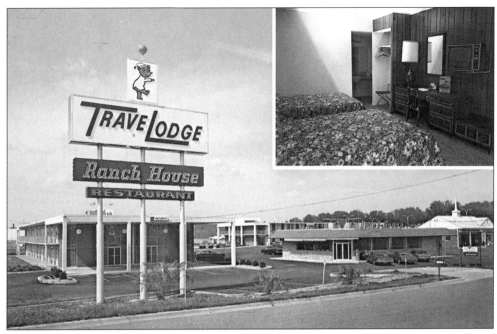

THE TRAVELODGE AND RANCH HOUSE ON SECOND STREET. The Lodge and Ranch House are now Econo Lodge and El Cazador Restaurant.

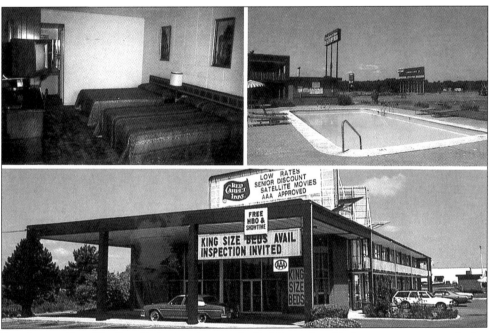

RED CARPET INN. The TraveLodge later became the Red Carpet Inn. Under new management the Inn is now Econo Lodge and is located on West Fifty-second Street next to Interstate 75.

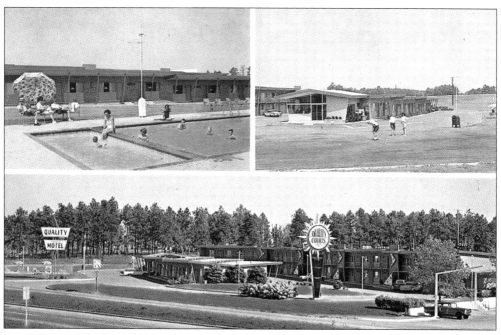

QUALITY MOTEL. This motel was at the intersection of US 82 and US 319. It was later changed to the Alpine Motor Lodge.

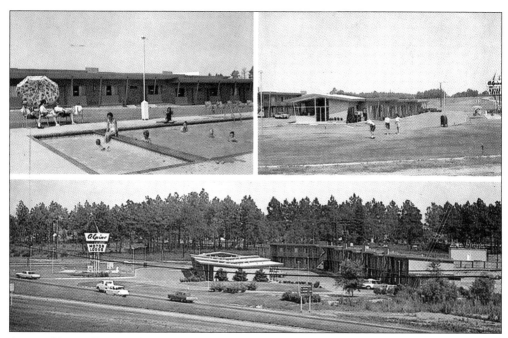

ALPINE MOTOR LODGE, FORMERLY THE QUALITY MOTEL. The trees in the background are in Oak Ridge Cemetery.

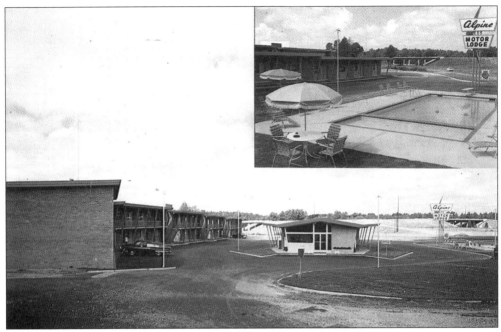

ALPINE MOTOR LODGE. This view of the Alpine Motor Lodge shows the new (late 1950s/early 1960s) Interstate 75, which runs north and south through Tifton. All of these buildings have been torn down and the land is currently vacant.

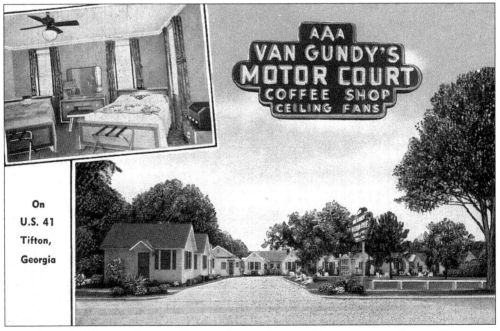

VAN GUNDY'S MOTOR COURT, COFFEE SHOP, CEILING FANS, RADIOS, STEAM HEAT AND CARPETED FLOORS. This store is still in operation on West Twelfth Street.

82

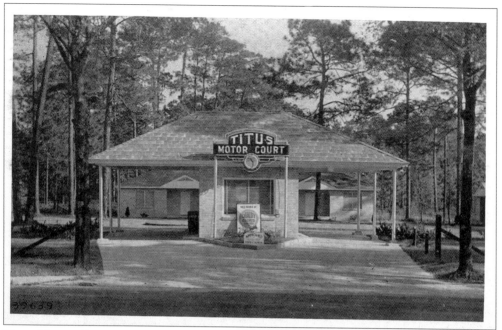

Titus Motor Court on the corner of Love Avenue and Twelfth Street. The motor court was recommended by Quality Courts and Duncan Hines. This card is postmarked March 11, 1949.

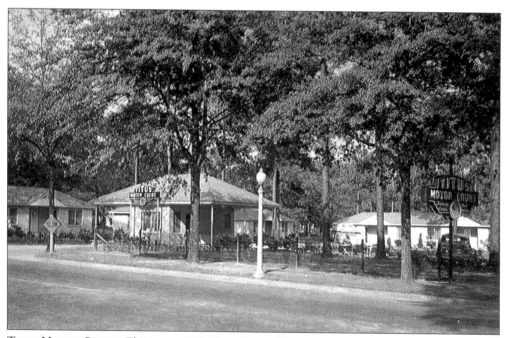

Titus Motor Court. This is now Mid-Town Estates. The motor court's rooms have been converted into small apartments and houses.

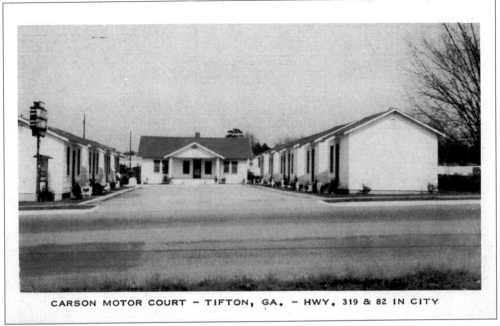

CARSON MOTOR COURT — TIFTON, GA. — HWY. 319 & 82 IN CITY

CARSON MOTOR COURT. This is an early postcard of the Carson Motor Court on Seventh Street.

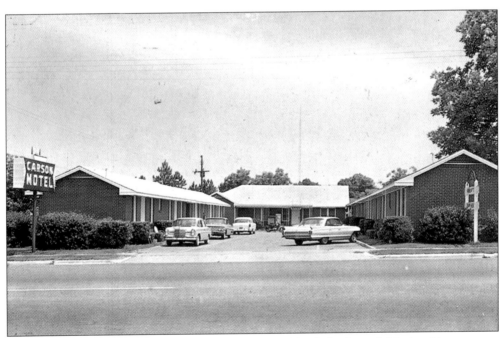

THE CARSON MOTOR MOTEL. This is the Carson Motor Motel after it was bricked and its name was changed from "court" to "motel." The motel is still serving the traveling public.

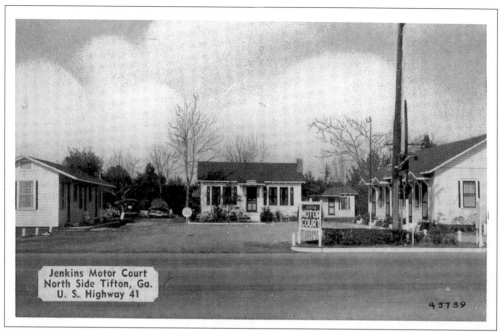

JENKINS MOTOR COURT. This motel on Twelfth Street had 10 clean, comfortable, newly furnished rooms with private baths. The court was replaced by office buildings.

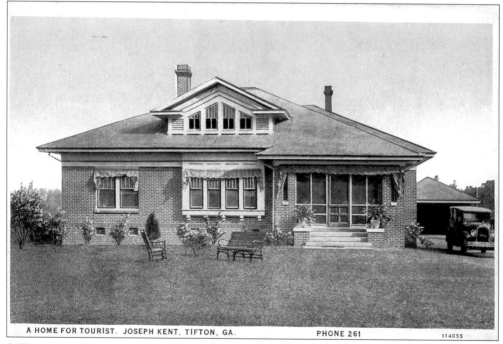

A HOME FOR TOURIST, JOSEPH KENT, TIFTON, GA. The postcard reads "The red brick house. A home when away from home. Steam heat, running water, garage, meals served, No Noise. If pleased tell others, if not tell us." Located on West Twelfth Street, it is now a private residence.

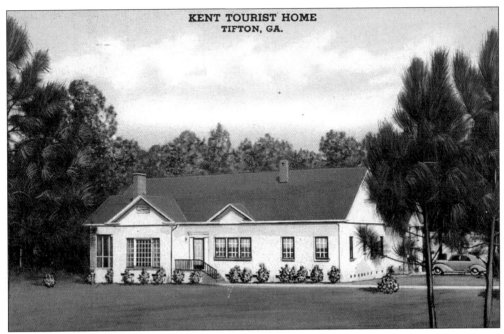

THE KENT TOURIST HOME. Located on North US 41, it offered gas heat in every room.

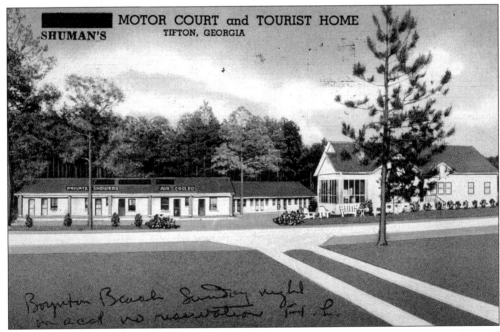

THE KENT TOURIST HOME. Mr. and Mrs. Marvin Shuman bought the Kent Tourist Home and "motel type rooms" were added. This card postmarked February 20, 1951.

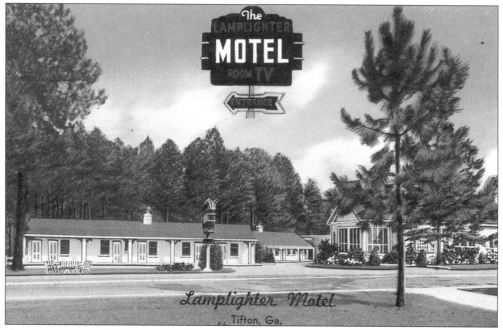

THE LAMPLIGHTER HOTEL. Later, the Shuman Motor Court and Tourist Home was sold to the Winkler family, who changed the name to The Lamplighter Hotel. Under new ownership and management, it is now famous for pizza and subs.

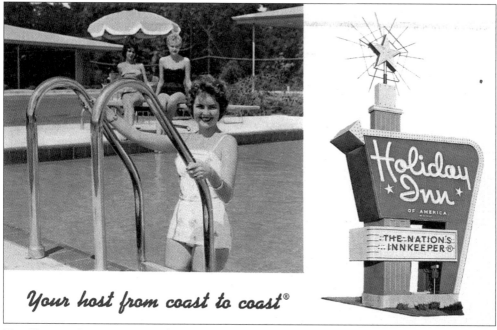

THE HOLIDAY INN IN TIFTON. This motel is next to Interstate 75 and US 82. This card is from the inn here in Tifton showing the old logo. The card is postmarked from Tifton on September 3, 1964.

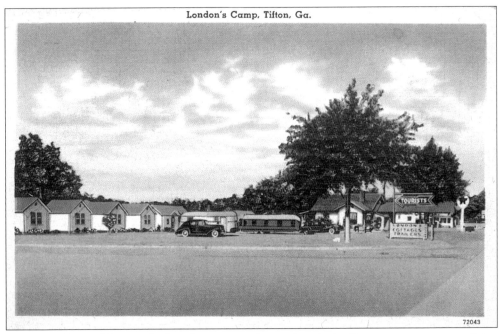

London's Camp, Tifton, Ga.

LONDON'S CAMP. This camp had modern cottages, heat, private baths, Beautyrest mattresses, a dining room, Texaco products, and trailer space. The camp no longer exists.

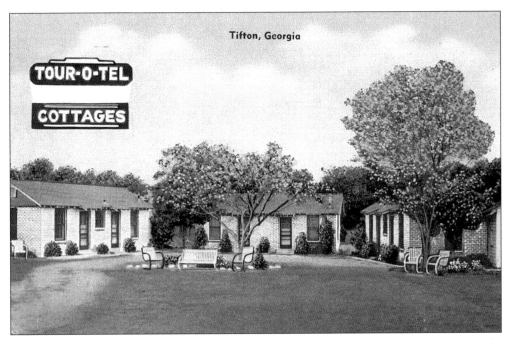

Tifton, Georgia

TOUR-O-TEL COTTAGES

TOUR-O-TEL COTTAGES. The cottages were described as, "New modern brick buildings, air cooled for the summer, automatic heat, all units with private baths and innerspring mattresses. Quiet and Restful."

TIFTON MOTOR COURT. This motor court advertised, "Clean, modern cabins, chicken and steak dinners." This card is postmarked March 16, 1946.

TIFTON MOTOR COURT. This view of Tifton Motor Court is postmarked September 7, 1952.

U. S. 41
3 mi. North of Tifton, Ga.

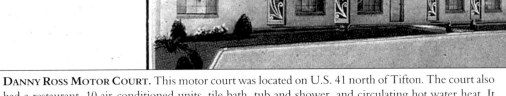

DANNY ROSS MOTOR COURT. This motor court was located on U.S. 41 north of Tifton. The court also had a restaurant, 10 air-conditioned units, tile bath, tub and shower, and circulating hot water heat. It had solid mahogany furniture and innerspring beds. The court and restaurant no longer exist.

Six

SPORTS AND
RECREATION

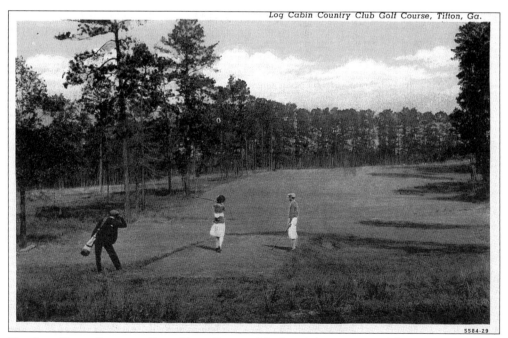

THE LOG CABIN COUNTRY CLUB GOLF COURSE. The Log Cabin Country Club is pictured with two golfers and one caddie. The area is now used for the Church of God Campground.

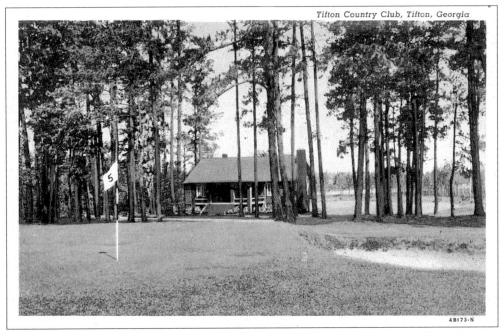

Tifton Country Club, Tifton, Georgia

4B173-N

SPRING HILL COUNTRY CLUB. This is also known as Tifton Country Club. The log cabin is shown in this picture. Spring Hill Country Club was later built on US 82 west of Tifton.

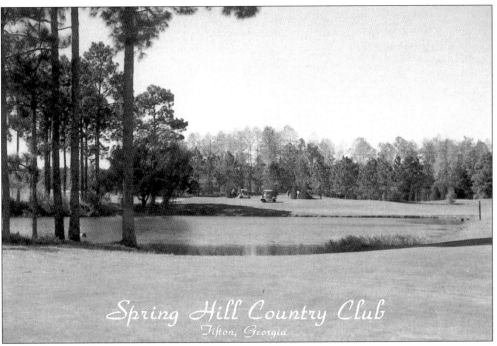

Spring Hill Country Club
Tifton, Georgia

SPRING HILL COUNTRY CLUB. The "new" Spring Hill Country Club has a very nice restaurant and a place to dance for parties and reunions besides the golf course. The golf course is also surrounded by many beautiful homes.

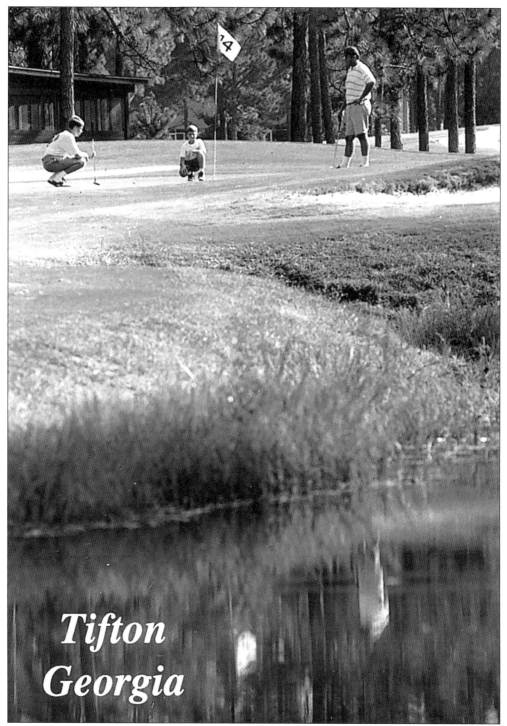

Tifton
Georgia

GOLFING IN TIFTON. Golf is a year-round delight in Tifton/Tift County, Georgia. There are three public courses at Spring Hill Country Club which draw golfers from around the world.

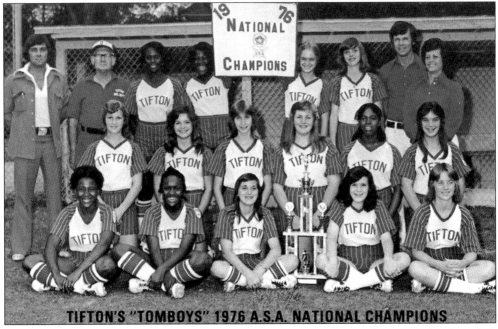

TIFTON'S TOMBOYS, A.S.A. NATIONAL CHAMPIONS, 1976. Tifton's Tomboys were the slow-pitch softball champions in 1976. Coaches E.B. Hamilton and Tommy and Carolyn Cottle are shown in the back row.

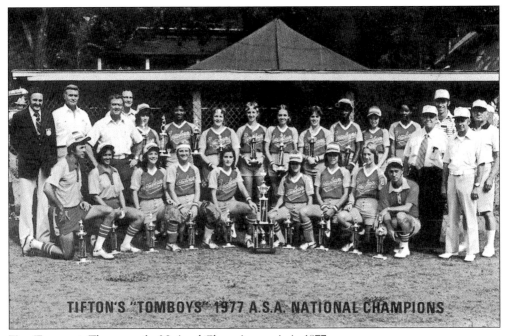

THE TOMBOYS. They were the National Champions again in 1977.

Seven
INDUSTRY AND AGRICULTURE

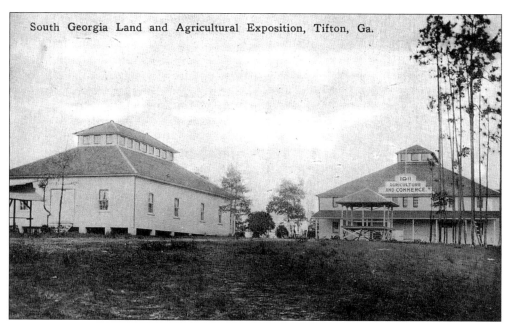

LAND AND AGRICULTURAL EXPOSITION. The South Georgia Land and Agricultural Exposition was held in Tifton. This card is postmarked January 18, 1917.

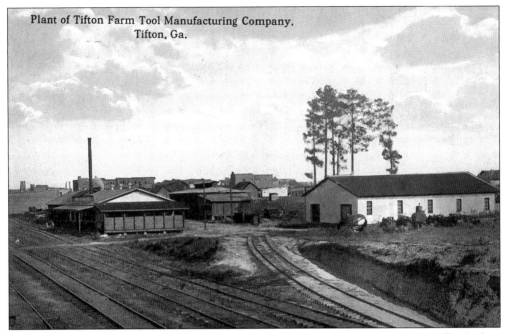

Plant of Tifton Farm Tool Manufacturing Company,
Tifton, Ga.

TIFTON FARM TOOL MANUFACTURING CO. In 1915 the tool company won first prize for the best county exhibit at the Georgia-Florida Fair.

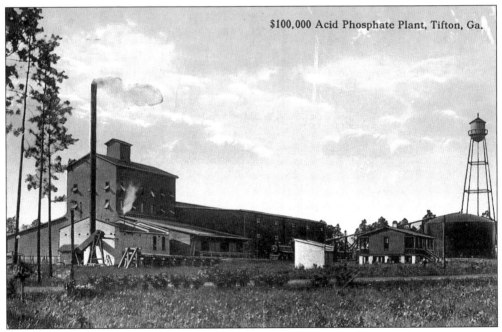

$100,000 Acid Phosphate Plant, Tifton, Ga.

THE $100,000 ACID PHOSPHATE PLANT. In October 1912, the International Chemical Company purchased from H.H. Tift 15 acres of land to erect for about $100,000 an acidulating plant, for the purpose of manufacturing commercial fertilizer.

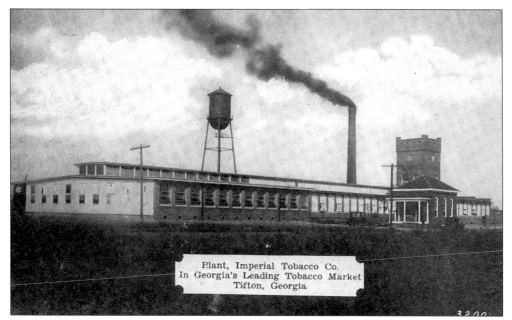

Plant, Imperial Tobacco Co.
In Georgia's Leading Tobacco Market
Tifton, Georgia

IMPERIAL TOBACCO CO. Years ago, Tifton had many tobacco warehouses downtown. They have either burned, been torn down, or are being used for other purposes. This is a picture of the Imperial Tobacco Co. The building still exists and part of it is now Groomingdale's for pet care.

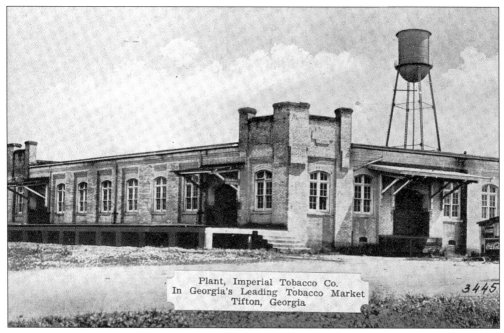

Plant, Imperial Tobacco Co.
In Georgia's Leading Tobacco Market
Tifton, Georgia

IMPERIAL TOBACCO CO. This is another view of the Imperial Tobacco Co. on the corner of South Ridge Avenue and Third Street.

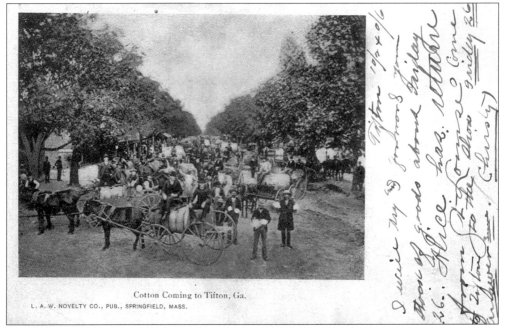

Cotton Coming to Tifton, Ga.

L. A. W. NOVELTY CO., PUB., SPRINGFIELD, MASS.

"COTTON COMING TO TIFTON, GA." This card is postmarked October 25, 1906.

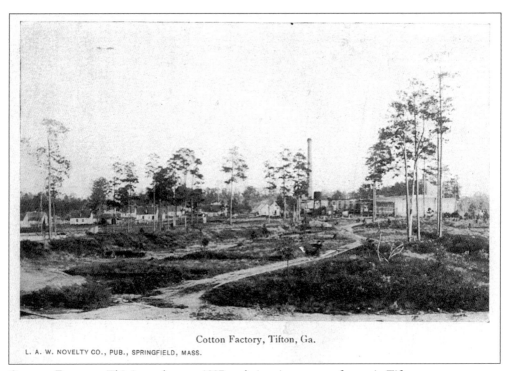

Cotton Factory, Tifton, Ga.

L. A. W. NOVELTY CO., PUB., SPRINGFIELD, MASS.

COTTON FACTORY. This is another pre-1907 card picturing a cotton factory in Tifton.

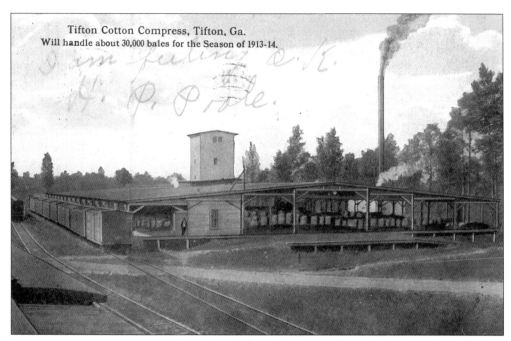

Tifton Cotton Compress, Tifton, Ga.
Will handle about 30,000 bales for the Season of 1913-14.

TIFTON COTTON COMPRESS. A 1914 postcard shows the Tifton Cotton Compress. The card states, "Will handle about 30,000 (bales) for the season of 1913–1914." It is postmarked August 7, 1914.

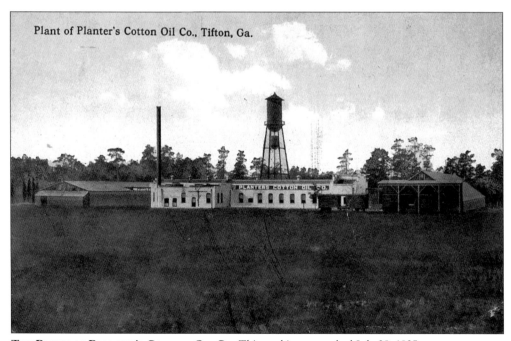

Plant of Planter's Cotton Oil Co., Tifton, Ga.

THE PLANT OF PLANTER'S COTTON OIL CO. This card is postmarked July 28, 1925.

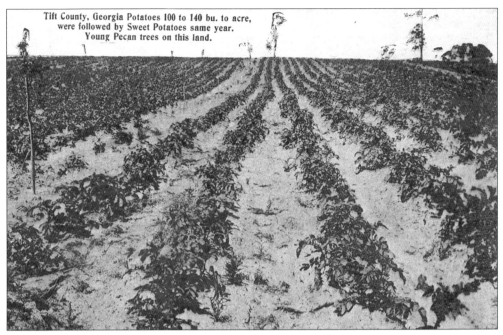

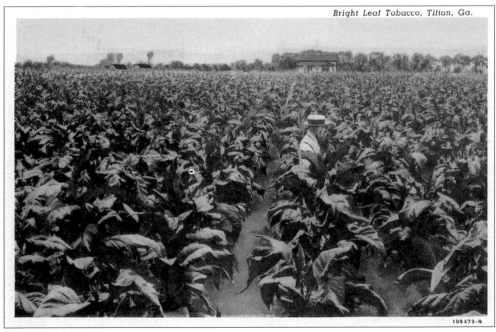

TIFTON FARMING. This card reads, "Tift County, Georgia Potatoes 100 to 140 bu. to acre, were followed by Sweet Potatoes same year. Young Pecan trees on this land." This is an early card prepared by the Tifton Chamber of Commerce.

BRIEF LEAF TOBACCO. This is Georgia's largest tobacco market. The card further states, "Tift County is Georgia's most successful diversified agricultural county."

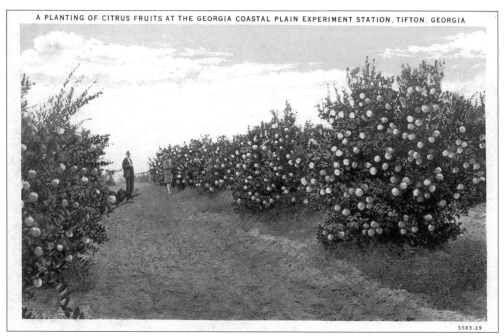

5583-29

CITRUS PLANTING. A planting of citrus fruits is seen at the Coastal Plain Experiment Station. Satsuma oranges, grapefruit, limes, kumquats and tangerines are grown here.

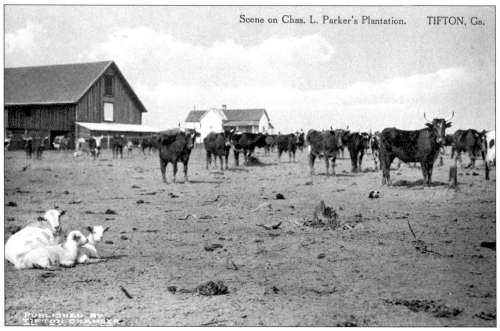

Scene on Chas. L. Parker's Plantation. TIFTON, Ga.

PUBLISHED BY
TIFTON CHAMBER

PARKER PLANTATION. This early card pictures a scene on Chas. L. Parkers's Plantation. The card was published by the Tifton Chamber of Commerce.

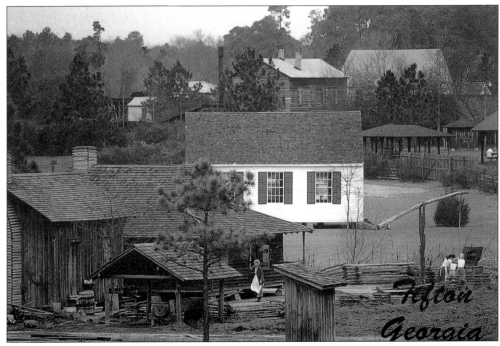

GEORGIA AGRIRAMA. The Georgia Agrirama in Tifton brings to life the landscape of South Georgia's farms and small towns in the late 1800s. The Agrirama's website address is www.agrigrama.com or call (229) 386-3344 for more information.

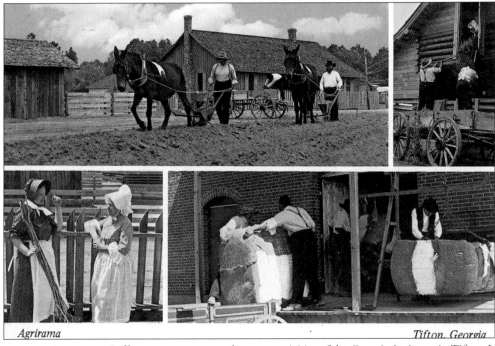

GEORGIA AGRIRAMA. Different scenes capture the many activities of the Georgia Agrirama in Tifton. It first opened to the public on July 1, 1976 and is dedicated to Georgia's important agricultural heritage.

Eight
THE COASTAL PLAIN EXPERIMENT STATION

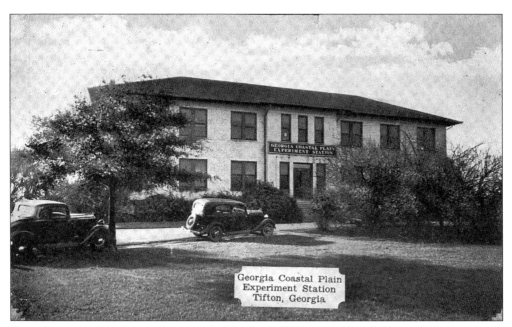

FIRST BUILDING. This is an early postcard of the first building at the Georgia Coastal Plain Experiment Station in Tifton. Note the 1930s automobiles.

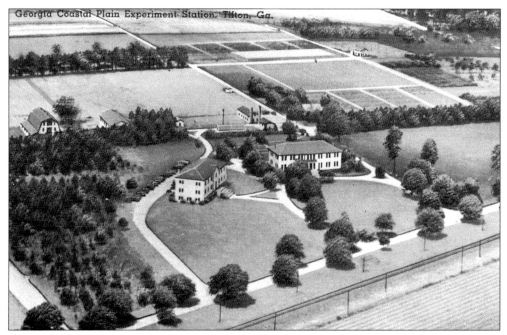

GEORGIA COASTAL PLAIN EXPERIMENT STATION. This is an early aerial view of the Georgia Coastal Plain Experiment Station in Tifton. The Tift Building on the right was constructed in 1922 for $17,000. The Formal Gardens shown below were located behind this building.

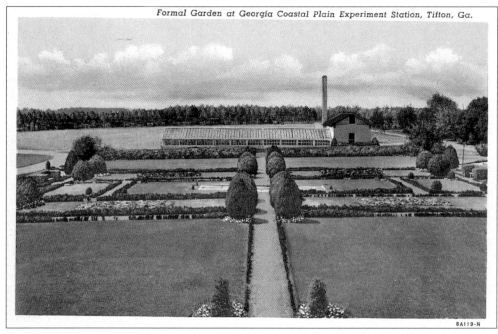

FORMAL GARDEN AT THE COASTAL PLAIN EXPERIMENT STATION. Tha Gardens later became a parking lot. A greenhouse is still located in this area.

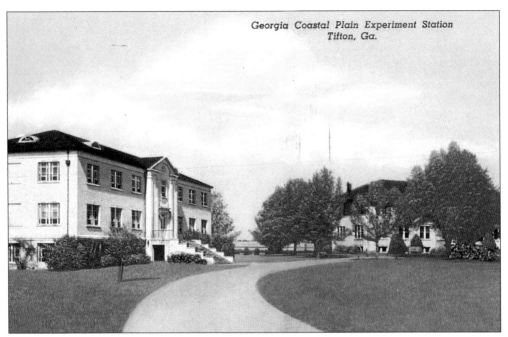

BUILDINGS AT THE COASTAL PLAIN EXPERIMENT STATION. The building on the left is the Animal Science Building, constructed in 1937. The Tift Building is on the right.

THE ADMINISTRATION AND LIBRARY BUILDING AT THE EXPERIMENT STATION. Constructed in the 1950s, this building houses the Director's office, a library, and conference rooms.

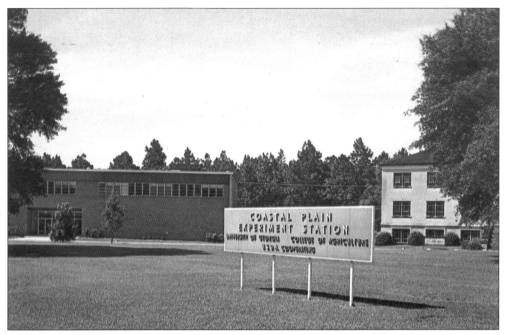

BUILDINGS AT THE EXPERIMENT STATION. The station is part of the University of Georgia College of Agriculture and employs both federal and state employees. Shown above is the Horticulture Building on the left and the Animal Science Building on the right.

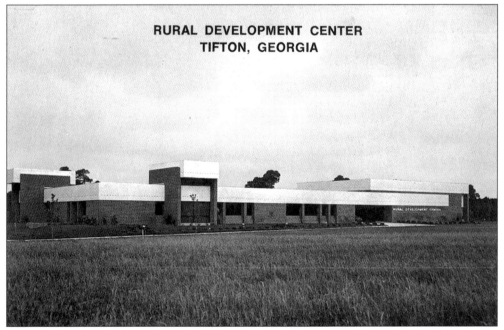

THE RURAL DEVELOPMENT CENTER (RDC). RDC is located near Abraham Baldwin Agricultural College and the Coastal Plain Experiment Station. The facility is used for research conferences and distributes information to farmers and to the public.

Nine
Ty Ty, Georgia

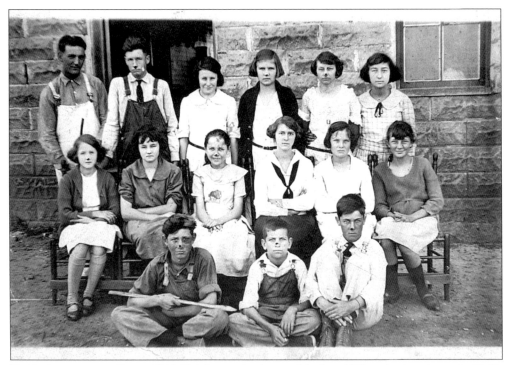

Ty Ty Graduating Class, 1925. This is an early picture of the later 1925 graduating class at the Ty Ty School Building. Pictured from left to right are (front row) Durwood Parks, Morris Stanford, and Leo Warren; (middle row) Frances Woodard, Annie Poole, Annie Cooper, Clothide Clark, Dollie Ross, and Ethel Sikes; (back row) Julian Ford, Hobart Willis, Sarah Ford, Frances Sikes, Nevie Pickett (teacher), and Nell Willis.

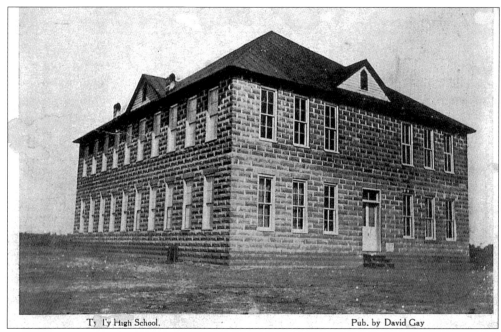

Ty Ty High School. Pub. by David Gay

TY TY HIGH SCHOOL. Ty Ty High School was built in 1904. Ty Ty is approximately nine miles west of Tifton. The second floor of this building was removed many years ago. Recently, the remaining ground floor of the building was remodeled and is now the Ty Ty City Hall.

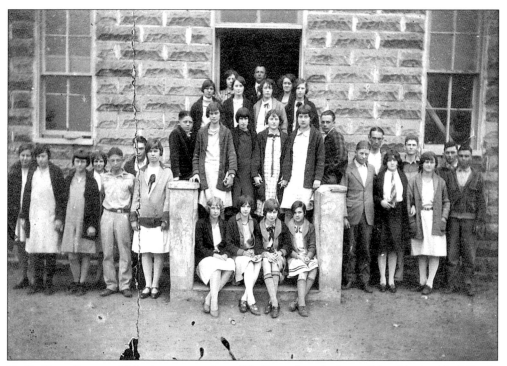

TY TY HIGH SCHOOL. This picture was taken of Ty Ty students in front of the old school building in the 1920s. Some of the students pictured were in the 1930 graduating class at Tifton High School.

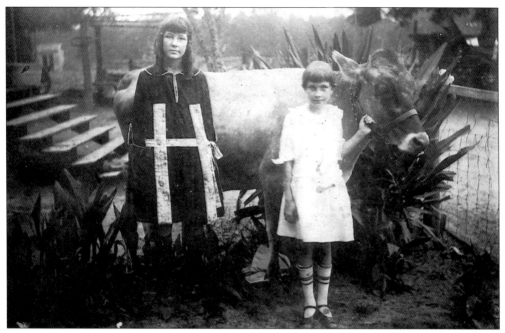

ETHEL AND FAY SIKES. Aunts of the author, the girls are standing in the yard of their parent's home on South Oak Street in Ty Ty, Georgia. Daisy, the cow, is also posing. Note the two holer (outdoor toilet) in the background.

THE 1925 TY TY HIGH SCHOOL GRADUATING CLASS. Seated in front is James I. Harrison, superintendent. Seated on the second row (left to right) are Dollie Ross, Clothide Clark, Annie Poole, and Frances Sikes. Standing (left to right) are Dana Whitfield, Nell Willis, Herman Terry, Sara Chesnut, Annie Lou Willis, Frances Woodward, Sadie Ross, Royace Swain, Ethel Sikes, and Morris Stanford.

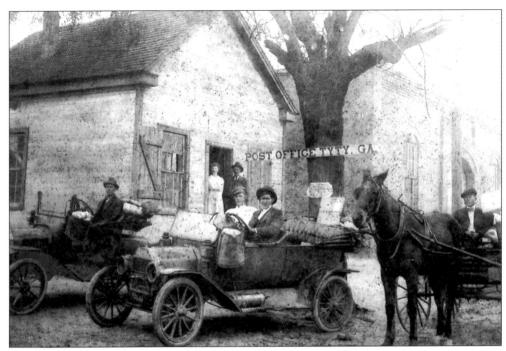

TY TY'S FIRST POST OFFICE, EARLY 1900S. The author's grandfather, William Fleck Sikes, is the driver of the second automobile from the left. Sikes delivered the mail for 42 years in Ty Ty, beginning December 1, 1905.

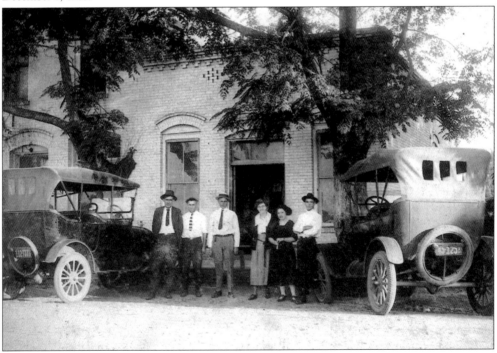

THE SECOND TY TY POST OFFICE. Employees pictured in 1922 are, from left to right, William Fleck Sikes, Earl Gibbs, Louie Monk, Maude Thompson, Ida Wetherington Williams, and J.M. Watson.

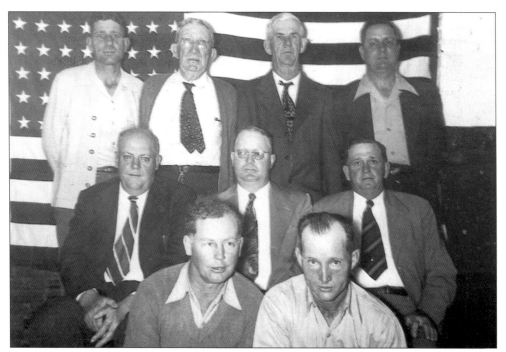

WOODMEN OF THE WORLD (WOW) TY TY, GEORGIA LODGE, 1949. The members of WOW are pictured in front of a 1948 American flag. Pictured from left to right are (first row) Alva D. Williamson and unidentified; (second row) Grady Gibbs, Chesley Sumner, and Thomas Cotton; (third row) Robert Mangham, William "Fleck" Sikes, Sikes Gibbs, and Ralph Shaw.

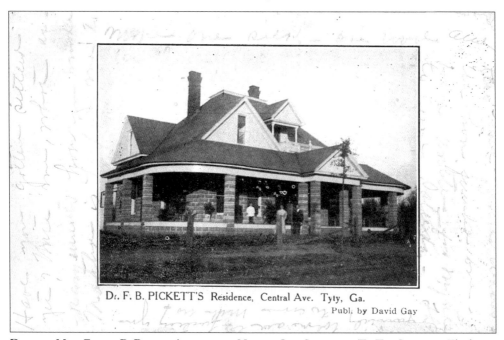

Dr. F. B. PICKETT'S Residence, Central Ave. Tyly, Ga.

Publ. by David Gay

DR. AND MRS. FRANK B. PICKETT'S HOME ON NORTH OAK STREET IN TY TY, GEORGIA. The home is now owned by a family member and is still in use.

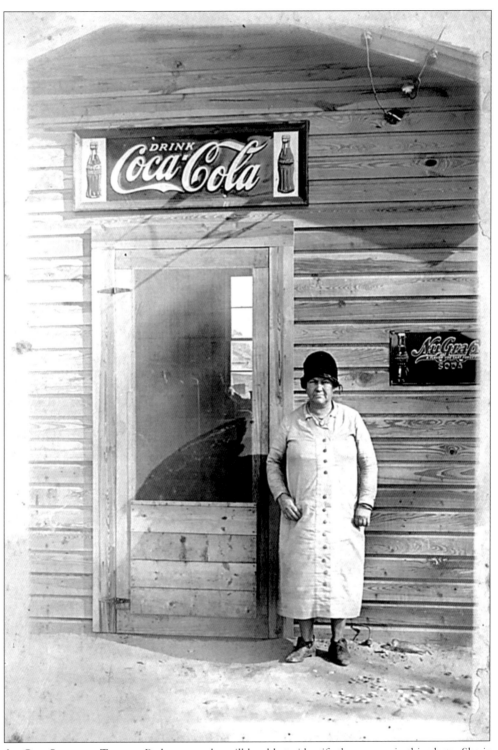

AN OLD STORE IN TIFTON. Perhaps a reader will be able to identify the woman in this photo. She is pictured in front of a store thought to be in Tifton.

Ten
MISCELLANEOUS

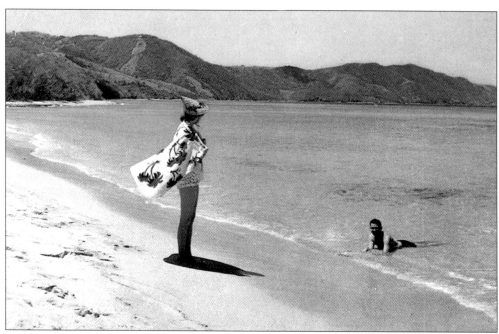

FAR FROM TIFTON! This picture of the author and his wife was taken soon after he finished college. His mother-in-law took them on a Caribbean Cruise. They visited all the islands, got off the cruise ship in St. Thomas, and flew to St. Croix where they spent two weeks. While there, the plantation owner where they were staying asked them to pose for a postcard picture. It would be used to advertise her plantation for guests who were looking for accommodations while visiting the island. The photographer of this picture was the world famous Fritz Henle.

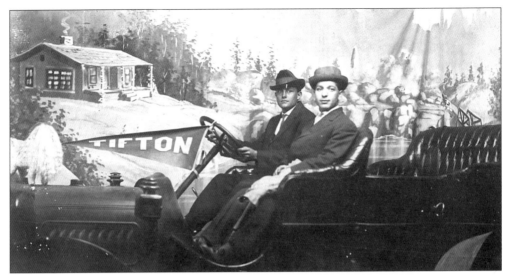

AN EARLY AUTOMOBILE. This postcard picture is featured on the cover of the book. The driver of the automobile is Joseph Hayes, an uncle of Claude Davis. Mr. Hayes was killed during World War I. The other man was an automobile dealer.

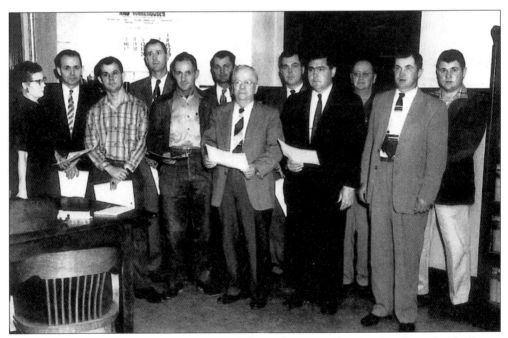

COUNTY LEADERS. Mrs. Leon Clements (far left), Ordinary, is administering the oath of office to 1956 Tift County Officials. Seen from left to right are Bowie Gray, Henry Bostick, Tom Greer, Bill Watson, Lee Ball, George Sutton, Bob Reinhardt, Henry Banks Allen, W.G. McNabb, Cliff Driggers, and Norris Windom.

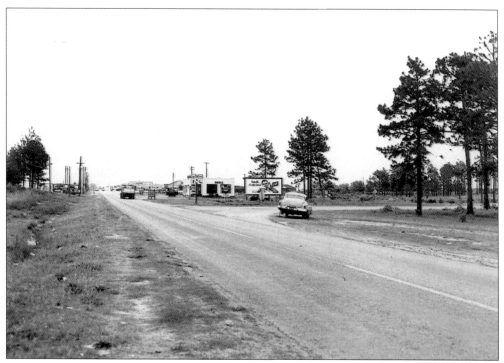

INTERSECTION OF U.S. 82 AND U.S. 319. This picture was taken in the 1950s during right-of-way acquisition for the Tifton Bypass, which later became Interstate 75.

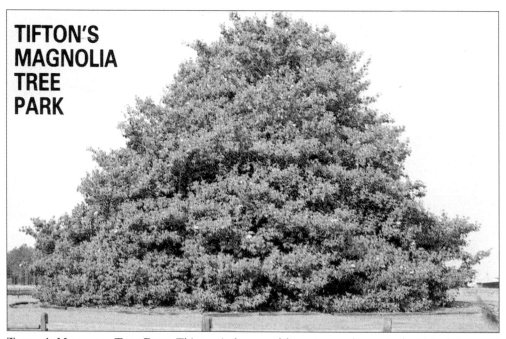

TIFTON'S MAGNOLIA TREE PARK. This tree is the second-largest magnolia tree in the United States and is known to be well over 100 years old. The postcard was distributed on a calendar in 1983.

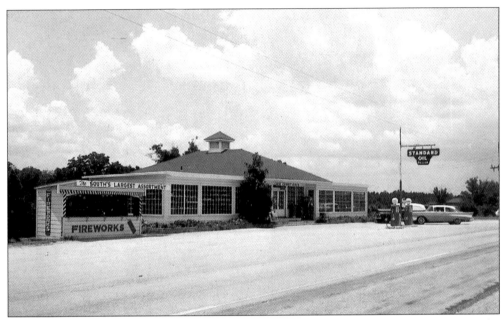

MAGNOLIA PLANTATION. The Magnolia Plantation was located on U.S. 41 approximately seven miles south of Tifton. This building was in use before the interstate was built.

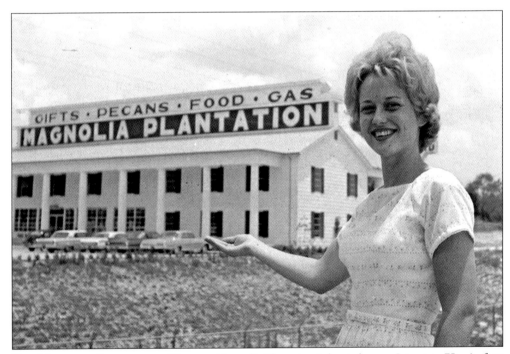

NEW MAGNOLIA PLANTATION. The new Magnolia Plantation is located on an Interstate 75 exit, four miles south of Tifton.

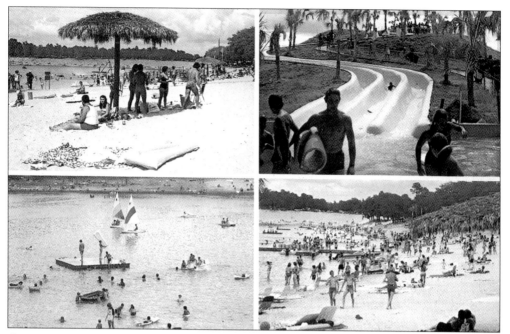

CRYSTAL LAKE. This was the closest beach to Tifton and resident traveled there to swim for many years. Sadly, it is now closed to the public. The lake is located approximately 15 miles from Tifton, in Irwin County.

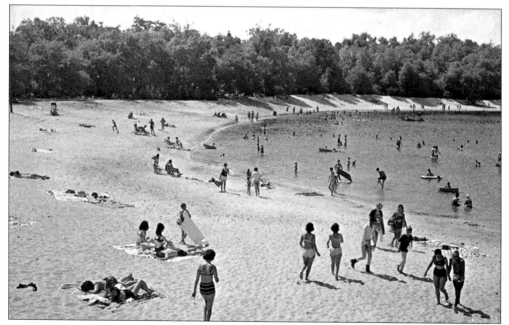

CRYSTAL LAKE. Bathers enjoy the beach at Crystal Lake.

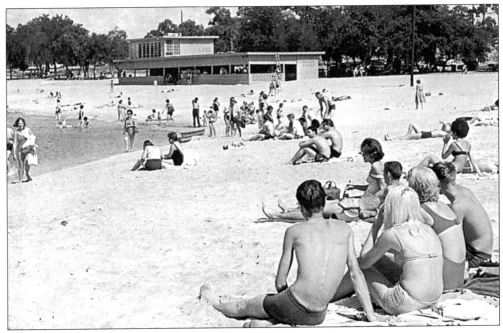

CRYSTAL LAKE. People are shown soaking up the sun at Crystal Lake.

CRYSTAL LAKE. Although Crystal Lake is not in Tift County, Tiftonites enjoyed the lake for many years.

SHOPPING IN TIFTON. Tifton has many quaint shops for the shopping lover. The Agrirama Shop offers everything from reproduced early toys to grits.

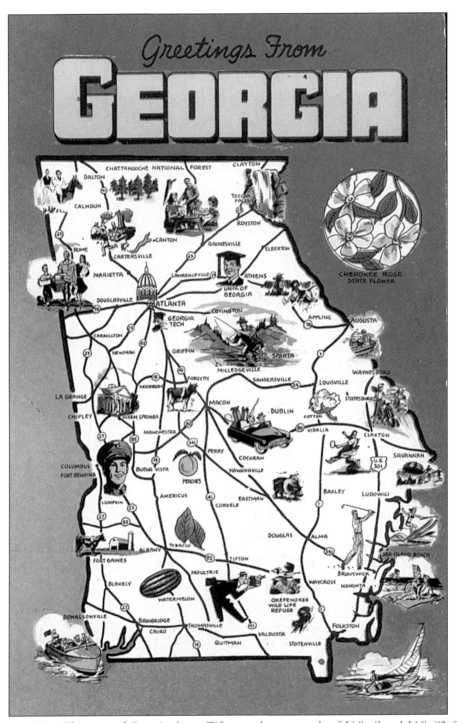

GEORGIA MAP. This map of Georgia shows Tifton as the crossroads of U.S. 4l and U.S. 82. The postcard was produced before the interstate was built.

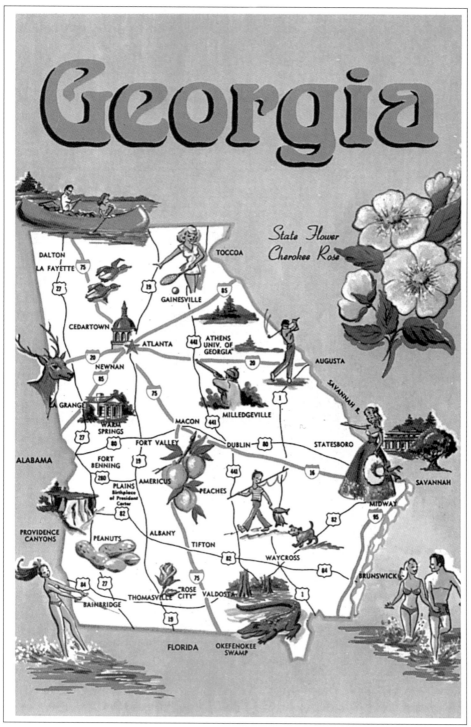

ANOTHER MAP OF GEORGIA. Another postcard map of Georgia shows Tifton at the crossroads of U.S. 82 and Interstate 75. Tifton is only 62 miles north of the Florida line.

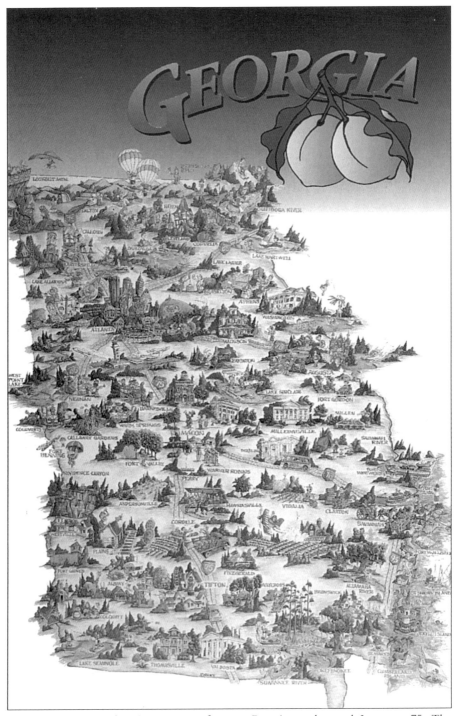

GEORGIA HAS IT ALL. This Georgia map features Georgia peaches and Interstate 75. There is something in Georgia for everyone—beaches, mountains, cities, and small towns.

FISHING IN TIFTON. Bass are big and so are the bream in the many fine fishing spots in Tift County.

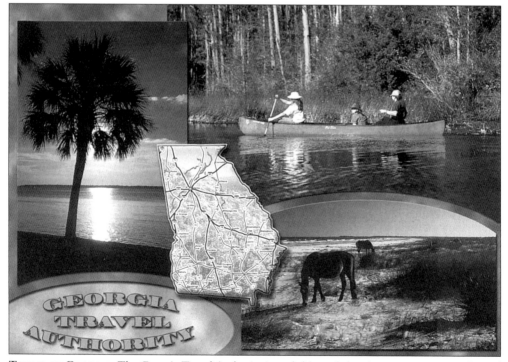

TRAVEL IN GEORGIA. The Georgia Travel Authority issued this card showing a sunset, canoe trip, and horses on the beach. Tifton is shown near the bottom of the card.

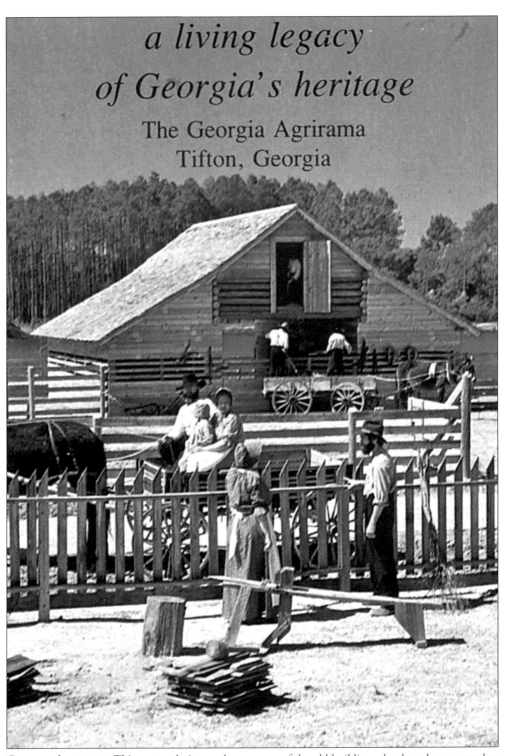

a living legacy
of Georgia's heritage
The Georgia Agrirama
Tifton, Georgia

GEORGIA AGRIRAMA. This postcard picture shows some of the old buildings that have been moved to the Agrirama to create this 19th-century rural living setting.

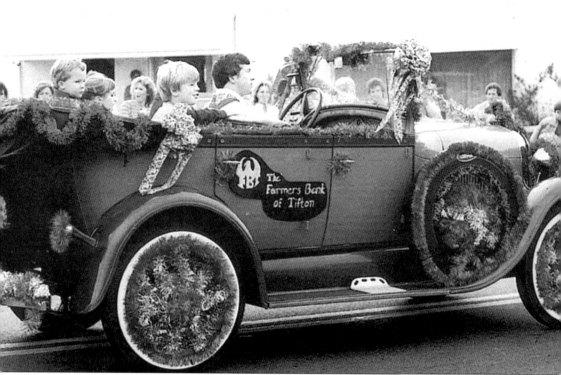

OLD AUTOMOBILES IN TIFTON. Because of my love of old automobiles, the following picture/postcards show old automobiles in Tifton. The buildings appeared earlier in the book but the old automobiles add to the setting. I owned and drove a 1959 Edsel, two-door, hardtop for many years here in Tifton. The old car received smiles, stares, thumbs up, and horn blowing. I hope you enjoy these pictures and I bet someone will say, "my dad had a car like that" or "I always wanted one of those." The picture shown on this page was on a calendar published by The Farmers Bank of Tifton in 1985. Michael Hammond is sitting in the back of the car on the left.

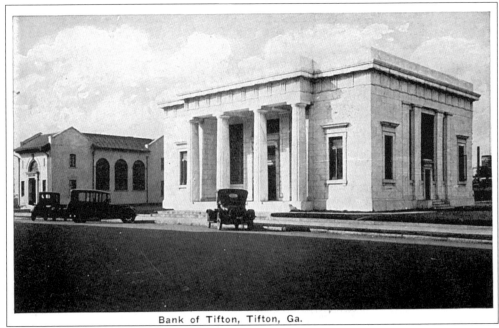

Bank of Tifton, Tifton, Ga.

BANK OF TIFTON. Old automobiles are parked in front of the then Bank of Tifton.

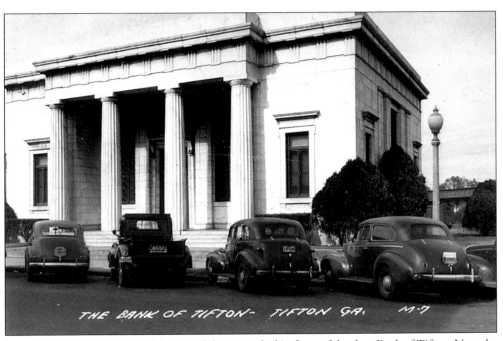

THE BANK OF TIFTON- TIFTON GA. M-7

MORE OLD AUTOS. Later-model automobiles are parked in front of the then Bank of Tifton. Note the Kent's Furniture truck.

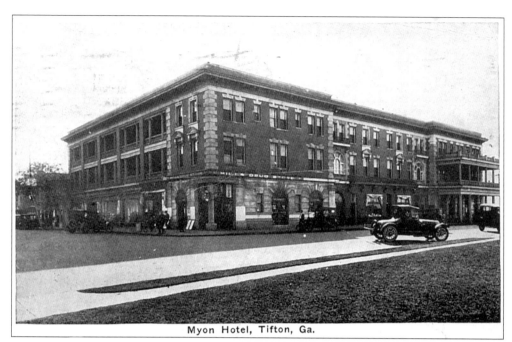

Myon Hotel, Tifton, Ga.

MYON HOTEL. The Hotel Myon is the setting for more old automobiles. This card is postmarked December 8, 1925.

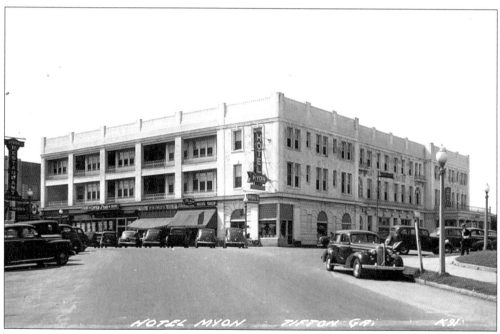

MYON HOTEL. This is a later scene of The Hotel Myon and other businesses with all the parking spaces filled with old automobiles.

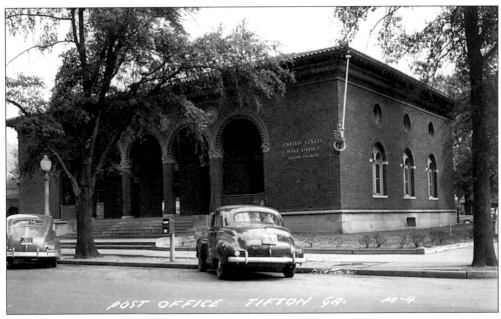

THE TIFTON POST OFFICE. The post office on Love Avenue is pictured with two old automobiles parked in front.

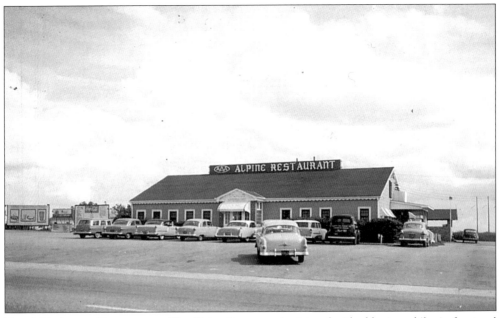

THE AAA ALPINE RESTAURANT. The Alpine Restaurant is pictured with old automobiles in front and undoubtedly lots of people inside enjoying the delicious food that was served there.